MW00574171

WHAT WOULD JESUS SEE?

WHAT WOULD WOULD JESUS SEE?

WAYS OF LOOKING AT A DISORIENTING WORLD

AARON ROSEN

Broadleaf Books
Minneapolis

WHAT WOULD JESUS SEE?
Ways of Looking at a Disorienting World

Cover design: Faceout Studio
Cover image: Roger Wagner (b. 1957), *Writing in the Dust*, 2016, oil on canvas,
31.3 x 38.8 cm. Collection: The Faith Museum, Auckland Castle. © The artist.

Print ISBN: 978-1-5064-7865-4
eBook ISBN: 978-1-5064-7866-1

To my love
Rev. Dr. Carolyn Rosen

CONTENTS

CONTENTS

The faith that others give to what is unseen, I give to what one can touch, and look at. My gods dwell in temples made with hands; and within the circle of actual experience is my creed made perfect and complete.

<div align="right">Oscar Wilde, De Profundis</div>

I don't want an invisible god. I want a god who is seen
but doesn't see, so I can lead him around
and tell him what he doesn't see. And I want
a god who sees and is seen. I want to see
how he covers his eyes, like a child playing blindman's bluff.

<div align="right">Yehuda Amichai, "Gods Change,
Prayers Are Here to Stay"</div>

And Jesus was a sailor when he walked upon the water
And he spent a long time watching from his lonely
 wooden tower
And when he knew for certain only drowning men
 could see him
He said all men will be sailors then until the sea shall
 free them
But he himself was broken, long before the sky would open
Forsaken, almost human, he sank beneath your wisdom
 like a stone

<div align="right">Leonard Cohen, "Suzanne"</div>

WWJD? What would Jesus do?

Growing up in rural America in the nineties, I remember this phrase was ubiquitous: bedazzled onto t-shirts, stitched into friendship bracelets, and scrawled across baggy jeans and backpacks with Sharpie markers. Whatever fashion sin was being committed, WWJD was a part of it. At the time I didn't think much of it. And it certainly didn't strike me as particularly original or interesting. Now, a full generation later, trained as a theologian, I see something different and surprisingly relevant in this innocuous acronym.

At its core, the question "What would Jesus do?" is a profound, even radical, one. In one form or another, it has rung in the ears of centuries of martyrs as they endured trials and torments for their faith. And it is the theme of some of the greatest works of devotional theology, most famously Thomas à Kempis's fifteenth-century classic, *The Imitation of Christ*. In the twentieth century, the Rev. Dr. Martin Luther King Jr. returned again and again to the need to recapture the fiery passion for justice that was the great refrain of

Jesus's ministry and that burned so brightly in his early followers. "By opening our lives to God in Christ," King declared in one sermon, "we become new creatures. This experience, which Jesus spoke of as the new birth, is essential if we are to be transformed nonconformists." Being a follower of Christ, for King, meant the courage to depart from the status quo, to imitate the original nonconformist, the true revolutionary: Jesus.

Looking around today, the question "What would Jesus do?" doesn't seem to be sparking the sort of nonconformity King was talking about. How, then, might readers of the Gospels in the twenty-first century reignite this kind of revolutionary fire, which holds us to higher—one might say, productively impossible—standards? How do we escape the logic of self-justification, whereby WWJD starts to mean simply WWID—what would I do? In this book, I propose a simple but strangely overlooked question within the question: "What would Jesus *see*?"

That question might seem a bit frivolous at first glance. Jesus was a doer, one might reasonably object, not a looker! He didn't get crucified for what he saw, but what he did and what he taught. Yet this is actually my point. For Jesus, seeing *was* doing. At the core of his short ministry was a recurring call to look at the world— and especially its most disadvantaged denizens—with

new eyes. This book does not take this only metaphorically, assessing Jesus's "worldview" or "outlook" in general terms. I want to look at *how* Jesus saw, *what* he saw, and *why* this is important today.

Few people in the history of the world have understood as clearly and intuitively as Jesus that the way we look at people is intimately entwined with how we treat them. The same gift to the same person can be an act of humble service by one person and a hollow gesture by another, with only the look in the donor's eyes dividing the two. One need only recall footage of Donald Trump imperiously lobbing tubes of paper towels to a crowd in San Juan, Puerto Rico—decimated just weeks earlier by Hurricane Maria—to know the difference. When we ask how Jesus would see such a scene, the answer should be painfully clear. Hear his unflinching words to the moral authorities of his day as he accused them of false charity:

> Woe to you, scribes and Pharisees, hypocrites! For you tithe mint, dill, and cummin, and have neglected the weightier matters of the law: justice and mercy and faith. It is these you ought to have practiced without neglecting the others. You blind guides! You strain out a gnat but swallow a camel! (Matthew 23:23–24)

One might decry the former president's publicity stunt as merely bad optics. But Jesus's point is far more searching and important. In his eyes, even *good optics* are bad when that's all they are. The pursuit of appearances—no matter how carefully scripted to follow the law—is viscerally revolting to Jesus. "It's a black fly in your Chardonnay," as Alanis Morissette would have it (no more nineties references, I promise). Or a dromedary, according to Jesus.

Jesus denounces hypocrisy viscerally—and visually—precisely because he values seeing. He knows what sight can accomplish when deployed correctly. It would be easy to mischaracterize Jesus's thoughts on vision as simple denunciations of sensory experience, whereby sight is irredeemably distracting, illusory, or duplicitous. In fact, Jesus stridently insists on the value of seeing so long as optics and ethics remain married to one another. In his Sermon on the Mount, he repeatedly emphasizes the spiritual value of making good actions visible when it's for the right reasons. He tells his disciples,

> You are the light of the world. A city built on a hill cannot be hid. No one after lighting a lamp puts it under the bushel basket, but on the lampstand, and it gives light to all in the house. In the same way,

4

let your light shine before others, so that they may
see your good works and give glory to your Father in
heaven. (Matthew 5:14–16)

Indeed, the sermon itself might be seen as a sort of
spiritual and sensory performance, and it is no won-
der that artists and filmmakers have often emphasized
the integration between its staging and message. The
seventeenth-century French master Claude Lorrain, for
example, created a grand painting in which Jesus and
his disciples seem suspended in air as they perch atop a
butte. Peasants gather in the meadows far below, obvi-
ously out of earshot yet nonetheless illuminated by the
message from on high. With typical éclat, David Hock-
ney painted his own gigantic version of Lorrain's com-
position in 2010, assembling thirty canvases into a work
measuring fifteen by twenty-four feet. This dramatic
scale—and its brilliant array of scorching oranges and
replenishing blues—makes it clear that sight is not only
a conduit for revelation, but one in its own right. And
the ability to partake of and transmit this joy offers *A
Bigger Message*, to take Hockney's title.

At its heart, Jesus's insistence on acts of visible good-
ness is downright simple, almost childish. When my
wife, an Episcopal priest, led children's worship early

in her career, she would gather kids and their families around in a circle before the end of their service, when they would process back into the central worship space. Together, they joined hands and often sang a familiar song inspired by Jesus's words in Matthew: "This little light of mine, I'm gonna let it shine." I attended from time to time to support my wife. As a practicing Jew, I must admit this unbridled expression of Christian optimism made me a little bit uneasy. And if you had told me that years later I'd end up writing a book entirely about Jesus, I would have been surprised, to put it mildly. I'll talk about how I came to do so—and why I think a Jewish perspective on Jesus can be illuminating—in a minute. But for now, let's return to the song. I hung back around the edges of the prayer circle with our toddler, doing some very faint clapping in case anyone happened to glance my way. It was not so hard for me to imagine "this little light" shining a bit too brilliantly, even blindingly, in the eyes of others, however well-intentioned. After all, what might seem warm and encompassing to the one doing the shining can just as easily be a floodlight to someone of another faith or culture.

When we spoke about it later—my clapping may have looked a little more recalcitrant than I thought—my

wife reminded me about the history of the song. While it might seem self-congratulatory, a hymn to privilege in certain settings, during the civil rights era it was a refrain of resistance. In numerous variations, often calling out specific injustices or forms of resistance, the song was popularized by the Freedom Singers, raising both support and funds for freedom rides and sit-ins. Fast forward to mid-August 2017, when white supremacists assembled in Charlottesville, Virginia, for a nauseating—and ultimately deadly—event titled "Unite the Right." As a diverse group of counterprotestors gathered peacefully on the streets, neo-Nazis in masks and helmets shouted at them, "Jews will not replace us!" In response, Rev. Osagyefo Uhuru Sekou and other faith leaders and activists broke into a rendition of "This Little Light of Mine." "It shook the Nazis," recalled Sekou. "They didn't know what to do with all that joy. We weren't going to let the darkness have the last word." Watching videos of the episode still makes my skin tingle. This simple melody at once unmasked the cowardice of the neo-Nazis and visibly uplifted the counterprotestors. Here was the kind of light Jesus was talking about, the kind I wanted my son to bask in. Prismatic, inclusive, but dazzlingly clear in the face of evil.

APPROACHES

As you might suspect already, this book is not a study of the historical Jesus or a work of New Testament scholarship. Those interested in the sprawling quest for the historical Jesus, which began in early modern Europe and stretches to the present, have abundant options. These run from credulous accounts validating much of the Gospel narratives as they stand to works of radical skepticism, which suspect that very little of the canon reflects things Jesus really said or did. My own intention is not to paint another portrait of the historical Jesus to hang on the wall alongside these offerings. There's a reason this book is called "What *would* Jesus see?" not "What *did* Jesus see?" I see the value in both questions, but my interest here is in the theological question, not the historical one.

The Jesus I am interested in is not the historical figure but rather the complicated protagonist of the Gospels, some of the most brilliant and influential pieces of literature of all time. I do not mean literature in a dismissive sense at all, as if there was no difference between Jesus and Jack Ryan in a Tom Clancy novel. I recognize that Jesus's messianic identity for Christians—as well as his prophethood in Islam—means that what I assert about Jesus's vision has unique relevance and implications for

practicing faith communities. Indeed, I hope much of what I say in this book will not only be respectful to those communities, but actually useful (more on that later). But I also believe that Jesus's ministry has important things to say to people who do not recognize him as holy—let alone divine—including people of other faiths, people who define themselves as spiritual but not religious, or outright atheists. By referring to Jesus as a character within the Gospels, I hope to establish how Jesus sees—and why we should care today—without anchoring my inquiry either in Jesus's historical personhood or divinity. What he says and does in the Gospels carries moral significance qua literature, by virtue of the insights he conveys. And while these insights may be deepened by a belief in their historical veracity, and especially their role in salvation history, they nonetheless carry theological weight on their own terms.

Because I am most interested in the character of Jesus during his ministry, and how he teaches us to see in new and meaningful ways, I will focus primarily on the Gospels, rather than the wider canon of the New Testament. There are, without a doubt, compelling ways in which sight features in the experience of Jesus's early followers, and I hope the present volume will encourage readers to sketch those connections themselves.

Certainly, St. Paul's calling—often misleadingly labeled a "conversion"—has profound sensory dimensions. Saul, as he was then called, is stunned by a blinding light and a booming voice who identifies himself as "Jesus, whom you are persecuting" (Acts 9:5). Saul is unable to see, eat, or drink until he receives the healing touch of Ananias, a disciple of Christ, and "something like scales fell from his eyes, and his sight was restored" (Acts 9:18). Physical sight and spiritual lucidity are inextricably linked in this episode. It is as if his senses—and with them his perception of reality—must be given a hard reset in order for his spiritual reboot to take place. While episodes like this one on the road to Damascus offer tempting excursions, our inquiry will remain focused more on the earthly life of Jesus than the resurrected Christ, who inspires Paul's ministry and writings.

The chapters ahead will be anchored by close, literary readings of scriptural episodes. The goal of these readings is not to provide a comprehensive biblical commentary. What continually captures my attention is how passages have been received over time, extending their "natural lives." Sometimes those interpretations will be clearly theological—ranging from the ancient Church Fathers to contemporary critics—and sometimes those connections will be more implicit or orthogonal, drawn from the

arts or popular culture. Rather than offering a "reception history," surveying how biblical references have surfaced over time, I am more interested in instances of "reception exegesis." This term, coined by two of my mentors, Paul Joyce and Diana Lipton, reminds us that biblical interpretations (and interpretive traditions) of previous eras not only shed light on the past, they may also open up insights in the present.

Exploring scripture in this way, I hope, will help us shine a fresh light on pressing issues in contemporary culture. My goal is not to position Jesus as the ultimate and only answer to these issues—that would be quite a peculiar position for a Jew to take!—but rather to draw him into productive, mutually enriching dialogue with the present. In my investigations, I take inspiration in part from theologian Ben Quash. In his recent book, *Found Theology*, Quash offers a compelling challenge:

> In God, human beings are constantly invited to *relate the given to the found*. The givens come alive only in this indefinitely extended series of encounters with new circumstances, and the Christian assumption ought to be that no new found thing need be construed as a threat to what has been given, for we have to do with the same God both in the given and in the found.

While Quash is speaking here specifically to Christians, I hope even non-Christian readers of the present book will bring a similar spirit of openness to *finding* theology in what follows. As we engage in our theological thought experiment, pondering what Jesus would see in the present, we will practice looking through the eyes of someone for whom the world is both given and found, divinely known and personally discovered. Whether one believes in Jesus as the Son of God or not, there is a profound and revealing beauty to be found in this vision.

PERSPECTIVES

I think people write books—or at least I do, anyways—to find out something about themselves. Many times, that something isn't clear until a project is well underway, and sometimes it's not until a good deal after the book is in print that it becomes clear what this motivation *really* was, the one behind the intellectual curiosity and professional pressures. This was certainly the case with my first book, *Imagining Jewish Art*, which grew out of my doctoral thesis. It wasn't until I was offhandedly describing the book to a friend one day—departing from the schtick I'd developed for job interviews and conferences—that I realized I'd inadvertently written a thinly disguised work of autobiography.

Growing up Jewish in rural Maine, in a town with one traffic light—and not that many more Jews—I implicitly saw Jewishness as something personal, intermittently familial, and only rarely communal. When one doesn't know many other Jews, it's easy—especially if the impression is reinforced by others, and not always charitably—to assume that one's personal eccentricities are somehow intrinsically Jewish. Later, I'd find my mantra in one of Franz Kafka's musings in his diaries: "What have I in common with Jews? I have hardly anything in common with myself." The exquisite irony, of course, is that this sense of alienation would come to be seen by Kafka's interpreters, especially Walter Benjamin, as inalienably Jewish. Enthralled by Kafka and Benjamin, during my graduate studies in Jewish culture I gravitated toward painters who conjured Jewishness in unexpected, highly individualistic ways. Rather than overtly Jewish subjects, I was interested in those moments when Jewish artists had to *find* Jewishness in places where it seemed invisible or even unwelcome. In retrospect, it was obvious: I was looking to art to help me figure out what it looked like, and what it meant, to assemble a Jewish identity for oneself; or, recalling Quash's discussion of "found theology," to become one's own *objet trouvé*.

This pursuit took me to the heart of the Western artistic canon and its inextricably Christian character. How, I started to ask, could a modern Jewish artist, *as a Jew*, not only make sense of this history, but make it one's own? Chaim Potok's novel *My Name Is Asher Lev* proved crucial in framing my inquiry. The eponymous protagonist—based partly on Marc Chagall, and partly on Potok himself—is a young Hasidic Jew struggling to reconcile his religious upbringing with his precocious talent as a painter. Under the direction of his community's rabbi, Asher Lev begins studying with a secular Jewish artist, Jacob Kahn, who takes Lev to the Metropolitan Museum of Art. Unnerved by all the paintings of Jesus, Lev asks to leave. His mentor chastises him:

> Asher Lev, you want to go off into a corner somewhere and paint little rabbis in long beards? Then go away and do not waste my time. Go paint your little rabbis. No one will pay attention to you. I am not telling you to paint crucifixions. I am telling you that you must understand what a crucifixion is in art if you want to be a great artist. The crucifixion must be available to you as form.

As Kahn makes clear, Jesus stands at the crossroads of Western art. One simply can't get around him. From a non-Christian perspective, it would be easy to see this presence simply as a stumbling block. And while some Jewish artists have certainly avoided Christian themes and symbols, what is remarkable is just how many— across the spectrum, from secular to observant—have felt compelled to create images of Jesus. This was true for the first generation of major Jewish artists in the late nineteenth century, including Mark Antokolsky and Max Liebermann, mid-twentieth-century masters like Marc Chagall and Mark Rothko, and now contemporaries like Adi Nes and Leni Dothan. While some artists have used the image of Jesus to call attention to antisemitic persecution—Chagall's *White Crucifixion* (1938, figure 7) is a classic example—Jesus has been much more than an icon of suffering. For generations of Jewish artists, depicting Jesus has been a crucial step in establishing and understanding their place in art history, and indeed Western culture more generally.

Studying how Jewish artists looked at Jesus provided an unexpected window into my own identity, helping me understand the creative freedom—both aesthetically and theologically—of looking at Christianity from the

outside in. In my own way, I had joined a long tradition of what Susannah Heschel calls "reversing the gaze" in her study of Rabbi Abraham Geiger's pioneering scholarship on the "Jewish Jesus." In the 1860s, Geiger hypothesized that Jesus was actually a Pharisee, a fact he believed the New Testament went to great pains to conceal. While this thesis eventually proved unlikely, it was nonetheless "ingenious" at the time, Heschel submits, for the way it pushed Christian scholars to look seriously at Jesus as a Jew while simultaneously providing bold new directions for Jewish theologians, who were encouraged to see Jesus's ministry as a movement *within* Judaism. Building on Geiger's legacy, the philosopher Martin Buber could reflect confidently in the mid-twentieth century, "From my youth onwards I have found in Jesus my great brother." Surveying the early years of Jewish scholarship on Jesus, Heschel concludes, "Just as Christians in every generation have created an image of Jesus to meet their social and political conditions, so, too, did the assimilating Jews need a Jewish image of Jesus to meet their own social and political situation. Telling the story of Christian origins from a Jewish perspective was an act of Jewish self-empowerment." While Heschel is referring here to the work of scholars, she could just as well be describing the way artists, in a similar "act

of Jewish self-empowerment," have redrawn the image of Jesus. For both theologians and artists from the late nineteenth century onward, Jesus proved to be unexpectedly approachable—even when his followers were not—and an unlikely fount of inspiration.

I have continued to be fascinated by Jesus in both my scholarship and my practice as a curator, focusing on interfaith dialogue. But where my early work centered on fresh ways of looking *at* Jesus, now I'm interested in looking *with* him. "Reversing the gaze" takes on yet another meaning as we ask what Jesus would see in the present. The reasons for this shift are multifactorial, as my father would say when making a medical diagnosis. But one thing is certain. I wouldn't be writing this book, and not in this way, if it were not for my students.

Over the years, I have taught in religious studies and theology departments at universities across the United States and the United Kingdom. But it is only over the past few years, as a professor at Wesley Theological Seminary, in Washington, DC, that I have taught seminarians. For the first time, all of my students are Christian, and almost all of them are studying to become clergy. A distinguishing feature of Wesley is our strong emphasis on field education. Every faculty member is required to team up with a clergy learning partner and work with a dozen

students over the course of two years as they undertake field placements with local pastors and chaplains. Being asked to co-lead one of these "Ministry and Mission" groups felt like a baptism by fire. While I'm no stranger to theological education, the pastoral responsibility for stewarding them through this crucial period in their calling weighed heavily on me. How could I help them grow in faith, I wondered, when it was not one I shared? And, more specifically, how would the Jesus I knew from art and scripture connect to the Christ they knew by faith?

What struck me immediately was how intimately, almost casually, they invoked Jesus. I remember one student sharing in an early session that they had kept trying to say no to Jesus when they first felt a sense of calling to ordination, but Jesus had kept saying yes and tugged them toward seminary. A murmur of agreement rippled through the room, with one student exclaiming, "That's *so* Jesus!," prompting a wave of appreciative laughter. The sheer intuitiveness with which the students seemed to recognize one another's personal relationships with Jesus left a lasting impression on me.

Not only was this a far cry from my own experience of God in Judaism, it was a good deal different from the ways in which I'd heard Christian clergy talk, especially over my many years in England, where clergy

often seem reticent to talk about their faith on a personal level and hesitant to chat about the second person of the Trinity. In all the time my wife spent in the Church of England's formal process of discernment for ordination—and even her years as a seminary student—she was never asked a question that her bishop in the States asked her right away: "What is your relationship with Jesus Christ?" Suddenly, co-leading a ministry class at Wesley, talking with my students about Jesus, I felt very Jewish and very British!

Over time, I found many more points of connection with my students' faith journeys than I expected. But one aspect particularly intrigued me. When we talk about calling—and maybe we don't do that as much as we should—we rarely consider the *sense* of calling. It became clear as I listened to my students that for most of them calling was characterized by a quite palpable sense of desire, a "pull"—or indeed a tug of war—between them and Jesus. And the way in which they narrated this experience over time felt much more embodied, sensorial, even *aesthetic*, than I ever would have guessed. They were, in other words, talking my language as a scholar of visual culture. While calling is often cast as simply receptive—as if it is only a matter of adjusting one's antennae in the right direction to pick up a divine transmission—it can

also be creative. That's not just a clever way of saying it's made up. It means that for those who experience a calling to ministry, it often demands that they reimagine and remake their worlds, including their self-image. As my students explored their calling at seminary, they were learning to see themselves in a new light. Put another way, they were getting better at looking through Jesus's eyes, and seeing what he saw in them.

While I certainly haven't written this book only for my students, it was important to me to write about Jesus in a way that my students could recognize. And, just as importantly, I wanted to write in the spirit of those sessions I shared with them, with the humility that comes from knowing one is a supporting character in other people's faith stories.

In those discussions, I learned to see my skepticism as a sort of burnishing tool, providing a productive friction when students seemed tempted to settle for truisms or bromides. If I run the occasional risk in this book of seeming a bit impious or ironic, I hope readers will see it similarly, not as an effort to undermine belief but to demand more of it, to refine it. Like Bishop Krister Stendahl, I find that "I have become even more convinced of the theological necessity of irony—and of its nobler cousin humor—as a safeguard against idolatry."

OVERVIEW

I've shared a lot thus far about my approach to this book. Soon enough, we'll start hearing more from our main character. In chapter 1, we'll examine the conditions and dynamics of sight in the Gospels, looking at how Jesus understands the process of vision; his keen eye for spectacle; and how others behold him. By attending to these sensory and social dimensions of sight as Jesus experiences them, we'll lay the foundations for subsequent chapters, in which we'll seek to look through his eyes at the world around us. Chapters 2, 3, and 4 will each focus on a different—though ultimately interrelated—mode of seeing, with powerful lessons for us today. We will begin with "Paying Attention," looking at the kind of focus that Jesus demands from his followers and how this connects to mindfulness in a sensory-saturated world. In "Discerning Truth," we will reflect on how Jesus distinguishes true from false appearances, in ways that bear upon contemporary questions of "fake news" and the representation of history. "Recognizing Others" will build upon this conversation by exploring Jesus's unique capacity to apprehend the dignity of those he meets as well as the many moments in which he is not only misunderstood but misrecognized. This will take us into a discussion of how we see and construct identity

today, especially in relation to religious, racial, and sexual difference. As we will see, a close study of Jesus's vision encourages and provides strategies for radical empathy, quite distinct from the way he is often invoked in contemporary politics.

By now, I hope it's clear why I'm writing this book and how I intend to do so. It remains only to mention *when* I'm writing this book, a fact that's a bit more complicated than simply glancing at its copyright. All writing—even when it pretends not to be—is imbricated within its times in complex ways, some visible to the author and some not. In that way, of course, this book is no exception. But these are, I venture to say, exceptional times— certainly the most extraordinary in my lifetime—and they have left an indelible imprint on my thinking, in both direct and subtle ways.

It's a strange time to be thinking and writing about the sense of sight. Touch has felt more precious the past couple years, at times forbidden and avoided due to fears of contagion. Hearing, too, has been recalibrated during the pandemic. The mundane and comforting noises that usually emanate from schools, parks, and restaurants disappeared for months, while the wail of sirens began to feel routine. But above all, this has been a period of searing images. Overwhelmed hospitals and staff

were photographed struggling to save patients from COVID-19. The murder of George Floyd by police—caught on video, tellingly—catalyzed mass protests for racial justice, which spread around the globe via social media. And, on the opposite end of the moral spectrum, a treasonous mob overwhelmed the Capitol building in Washington, DC, brazenly documenting and sharing their crimes in real time. Meanwhile, the world barely had the attention span to focus on spiraling conflicts, from the Middle East to Eastern Europe; or ecological catastrophes of biblical proportion, from forest fires to flooded coastlines. For some, indeed far too many, the myriad traumas of the early 2020s have been experienced firsthand. But even when mediated through screens, these events were ubiquitous and unnerving, and their consequences inescapable.

Amid this maelstrom, it is almost hard *not* to look to the horizon with eschatological dread. The imagery of W. B. Yeats's poem "The Second Coming"—written a century ago, in the aftermath of the First World War and another devastating pandemic—feels eerily evocative:

> Turning and turning in the widening gyre
> The falcon cannot hear the falconer;
> Things fall apart; the centre cannot hold;

Mere anarchy is loosed upon the world,
The blood-dimmed tide is loosed, and everywhere
The ceremony of innocence is drowned;
The best lack all conviction, while the worst
Are full of passionate intensity.

The world didn't end, of course, in 1919, and it is unlikely to end now, even as "things fall apart" at what seems to be an even more dizzying rate. But like Yeats, who sharpened the imagery of Revelation against the whetstone of his times, we can find moral clarity by casting a biblical eye on the woes of our own epoch. This is not so despairing as it sounds. The more unflinching this gaze—the more it seems to confirm our damnable condition—the keener its redemptive, transformative force.

When we ask what Jesus would see today, it's hard to imagine he would be pleased. But just as he did in his own era—in a Holy Land rife with conflict, injustice, and uncertainty—he would surely find hope stubbornly commingled with despair. In a moment when our eyes have grown weary and unfocused, Jesus offers a vision of sight replenished and retrained on what really matters.

EYE TO EYE

Chapter 1

The study of religion has a vision problem. One might even call it congenital, dating back to the birth of the field in the nineteenth century. For generations, scholars of religion pored scrupulously over sacred texts, rarely looking up to examine "lived religion" (as if there's any other type!). Over the last couple decades, a corrective surgery of sorts has taken place. Rather than treating popular practices and images as peripheral concerns, scholars of religion have increasingly recognized sensory experience as a central aspect of religious experience, both as we understand it in the present and in the past.

A key figure in "bringing the spiritual to its senses," as he puts it, has been S. Brent Rodríguez Plate. "We make sense out of the senses," he reminds us. "This is the first true thing we can say about religion, because it is also the first true thing we can say about being human. We are sentient beings, and religion is sensuous." Plate's point is central to my own work, and it suggests why it's so rewarding to bring Jesus's visual insights to bear on the present. The world that both he

and we inhabit invites—even *demands*—that we make religious meaning through the senses. It might sound strange at first to think of Christianity in general, or Jesus in particular, in communion with the "sensual relations with the world," as Plate puts it. Yet Christianity, we do well to remember, stakes its entire existence on this fact. For Christians, God did not become incarnate in some esoteric invisible realm beyond the senses. It was precisely into this messy material world, Christian theology asserts, that the Son of God was made flesh.

The art historian Leo Steinberg reminds us that any discomfort we have admitting the sensuousness of both Christ and Christianity is the product of our own carefully curated obliviousness. Steinberg makes this case provocatively by pointing out the extraordinary number of Renaissance masterpieces, from nativity scenes to crucifixions, which overtly depict Christ's genitalia. In fact, works like Hans Baldung Grien's *Holy Family* (1511) go out of their way to have characters literally point at Christ's penis! While we might blush, or awkwardly explain away such images, they make a crucial theological claim: Christ's palpable sexuality was "not shameful, but literally and profoundly 'shame-less'" as the New Adam, born without Original Sin. Just as importantly,

this truth was meant *to be seen.* "I should feel defeated," opines Steinberg, "were these works taken as illustrations of texts, or of theological arguments. . . . They are themselves primary texts." In other words, our refusal to take visuality and sight seriously as modes of theological and devotional practice—even when looking *right at* devotional art—can render us unable to properly appreciate religious belief.

In this book, I'll often make recourse to works of art, sometimes as commentaries on scriptural passages, sometimes as "primary texts" in their own right. But our investigation will also take less traditional subjects as worthy of detailed visual analysis. While the Gospels don't tell us about Jesus looking at art per se, they do supply ample examples of his intensely visual way of engaging his world, and especially the people in it.

We won't just consider ancient examples. We'll seek out Jesus—and look as he looked—at a whole range of contemporary examples, from film and television to social media. I am guided in this work by the scholar David Morgan, who helpfully coined the term *sacred gaze* to describe the various factors that feed into religious seeing. As Morgan points out, when we see something as sacred we draw upon a whole range of ideas, practices, and conventions, which emerge out of our

social, cultural, and historical setting. Vision, especially in a religious context, is never as simple as it might seem at first glance. With this insight in mind, we're ready to examine how Jesus turns his sacred gaze on the world around him, and how he understands the physical, phenomenological, and social dynamics of sight.

A TOUCHING SIGHT

Let's begin with the basics: How does Jesus think sight actually works? For starters, he treats the anatomical and theological aspects of sight as inextricable. The religious world in which Jesus was immersed placed immense importance on bodily matters, the correct regulation of which had direct implications for ritual purity and impurity. And this in turn dictated the terms of one's relationship with *the social body*—that is to say, the people Israel—and their God. It is easy to see, then, why long passages of biblical books such as Leviticus—sometimes unfairly written off by Christian readers as "legalistic" or "boring"—delve into the particularities of bodily behavior with such passionate specificity. When it comes to maintaining an intimate relationship with a jealous and discerning Divine, no matter is too trivial. From this perspective, the *gift of sight* (a telling turn of phrase) is intrinsically theological.

In a revealing moment from his Sermon on the Mount, Jesus offers advice that sounds rather like a doctor confronting a recalcitrant patient at their yearly checkup.

> The eye is the lamp of the body. So, if your eye is healthy, your whole body will be full of light; but if your eye is unhealthy, your whole body will be full of darkness. If then the light in you is darkness, how great is the darkness! (Matthew 6:22–23)

Jesus's ophthalmic advice introduces several key insights for our inquiry. Physical and moral health here are inseparable, even indistinguishable, with "healthy" sight serving an almost inoculative function and "unhealthy" sight spreading rampantly like an infection. It is important to recognize the ableism encouraged by this kind of language and how damaging equivalences between physical and moral insight can be for the visually impaired. Jesus, speaking from a vastly different cultural context, has other primary concerns. To say that the eye is the proverbial window to the soul would seem to put things too passively for Jesus. By declaring the eye a "lamp," burning and emanating, he invites us to think about it engaging the world not as a passive recipient or even processor of information but as a dynamic force that engages the entire body and soul.

While Jesus saw himself as a rabbi rather than a philosopher, his remarks do resonate with a key debate among philosophers in antiquity over the nature of sight. In short, Greek philosophers—and their long line of successors, up through the Renaissance—argued over whether sight was essentially a matter of extramission or intromission. According to the first theory, that of extramission, the eye emits tiny particles or beams of light—what Plato calls "fire"—that reach out toward the object in question. In the latter model—intromission, favored more by Aristotle—the eye receives what amounts to ripples through the ether, broadcast by objects. For all their differences and ambiguities, both theories imagine sight as a process in which the seer and the object of sight are *connected*, not just metaphorically but substantially, by some mysterious effluvium. While Jesus probably wasn't aware of the intricacies of such theories circulating in the Hellenistic intellectual culture of his time, he does seem to share a similarly tangible sense of sight. And, if we want to press further, Jesus's image of the eye as a "lamp," and his recurring language of projection, seem to place him in the extramission camp.

The active—or indeed, wandering—eye is the subject of Jesus's most famous statement on seeing. As he expounds on his relationship to the Tanakh, the Hebrew

scriptures, Jesus makes clear to his disciples that he has not come to dismantle or even blur the bounds of the law, but rather to ensure that God's commandments are followed in their most expansive and morally challenging sense. In the memorable translation of the King James Version, Jesus declares, "Till heaven and earth pass, one jot or one tittle shall in no wise pass from the law, till all be fulfilled" (Matthew 5:18). Jesus seizes upon the example of adultery, prohibited by the Ten Commandments, to illustrate this principle.

> You have heard that it was said, "You shall not commit adultery." But I say to you that everyone who looks at a woman with lust has already committed adultery with her in his heart. If your right eye causes you to sin, tear it out and throw it away; it is better for you to lose one of your members than for your whole body to be thrown into hell. (Matthew 5:27-29)

It's certainly possible that Jesus was exaggerating for effect. Nonetheless, there were rumors in the early church that Origen, one of the most brilliant of the Church Fathers, took such talk of "members" so seriously that he castrated himself, like those who "made

themselves eunuchs for the sake of the kingdom of heaven" (Matthew 19:12). More recently, Jimmy Carter referred to Jesus's words when he confessed during the 1976 presidential campaign, "I've looked on a lot of women with lust. I've committed adultery in my heart many times." While the born-again peanut farmer left his eyes intact, he seemed genuinely penitential, which apparently struck some conservatives as insufficient and other voters—certainly readers of *Playboy*, where the interview appeared—as a bit too self-flagellating.

What risks getting lost in both the theological and cultural reception of Jesus's depiction of lust is what it reveals about sight itself. Lascivious looking is not just a precursor to the "real" sin, it is for all intents and purposes its own form of consummation. Read with the notion of extramission in mind, in which the eye reaches out for what it beholds, it seems no wonder that the stakes of sight are so high for Jesus. Ironically, while this moral vision might sound puritanical, Jesus's emphasis on sight as a form of haptic desire actually makes him startlingly modern. "Since the same body sees and touches," the phenomenologist Maurice Merleau-Ponty argues, "visible and tangible belong to the same world." However dramatically different their contexts and worldviews, Jesus would seem to have no

trouble agreeing with Merleau-Ponty that "vision is a palpation with the look." And while this may not literally describe the mechanics of sight, it does express how it *feels* to regard the corporeal world, and especially the people in it.

VISION RESTORED

Jesus not only tells us what he thinks about sight, he shows us. At key junctures throughout his brief but mesmerizing ministry, Jesus conjures visual spectacles in order to prompt reflection not only about what has just transpired but about the act of looking itself. In the following two cases I consider, Jesus holds a mirror up to the scornful gaze of crowds, directed at perceived sinners, and reflects it back with blinding clarity. Those who look with false conceit upon the sins of others—whether real or imagined—suddenly find themselves the object of unflinching judgment. What emerges is a reordering of the social economy of sight, which elevates proper seeing, focused on respect—including self-respect, it is important to note—while maligning acts of looking meant to shame or disgrace. Jesus is the ultimate arbiter, and those who fail his "vision test" stand to lose their sight, whether in this world or the next. "I came into this world for judgment," Jesus pronounces, "so that

those who do not see may see, and those who do see may become blind" (John 9:39).

As we examine the visual dynamics of shame and compassion, it is perhaps no surprise that we again find ourselves dealing with a case of adultery. This time, though, our lens pivots from personal desire and self-reflection to witness and judgment in the public square. As Jesus teaches at the Temple Mount, his adversaries bring before him a woman "caught in the very act of committing adultery" (John 8:4), attempting to place him in the unwinnable position of either endorsing her death by stoning or siding with a sinner. The way this narrative is framed encourages readers to assume the woman's guilt is undeniable, although there is good reason to be suspicious of this, even within its own cultural context (it's also worth noting that the episode is a late addition to the Gospel, not present in early manuscripts). After all, no mention is made of her romantic "accomplice," who would be equally liable for punishment according to Jewish law (Leviticus 20:10). Moreover, Jewish law stipulates that "a person must not be put to death on the evidence of only one witness" (Deuteronomy 17:6). Despite these legitimate concerns, Jesus does not attempt to question the accusation itself, as we would expect from a modern-day defense attorney. Instead, he interrogates and inverts the

spectacle of judgment, in which this woman has been stripped of her dignity and made to "stand before all of them" (John 8:3). Transposing the scene into the modern Middle East, the painter Roger Wagner depicts everyone whipping out their smartphones to capture this cruel circus, inviting us to imagine the added shame of replication, through endless shares online (figure 1).

Many of us know by heart what Jesus says next to the assembled masses: "Let anyone among you who is without sin be the first to throw a stone at her" (John 8:7). But Jesus's actions, which bookend this declaration, are just as integral to his message. I've heard preachers say Jesus "drew a line in the sand," but the scriptural text is

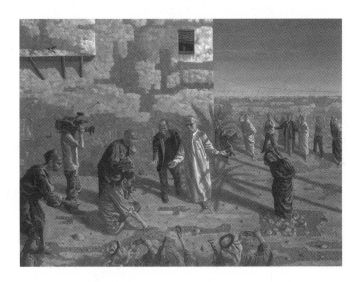

far more enigmatic. All we are told is that "Jesus bent down and wrote with his finger on the ground," not once but twice (John 8:6 and 8:8). This act is so strange and unexpected, it seems almost unbelievable that the Gospel does not tell us what he wrote! But perhaps this is the point. The Gospel focuses our attention on the *act* of inscription, and we share the perspective of the Pharisees gathered around Jesus, trying—and failing—to decipher his ephemeral marks. In a brilliantly simple act, Jesus pulls the imperious gaze of the crowd away from the suffering woman and redirects it to the dirt, turning certitude to confusion. One can well imagine the people around him, expecting a dramatic scene to unfold, shuffling awkwardly from foot to foot as Jesus scribbles away.

In *Writing in the Dust*, Rowan Williams recalls the events of September 11th, when he found himself stranded amid the smoke and miasma of Lower Manhattan as the towers fell. For Williams, Jesus's actions suggest a way forward in the wake of the tragedy and confusion of 9/11. Instead of yielding to the throng's thirst for immediate retributive justice, the ephemeral act of writing in the dust causes people to pause, creating space for reflection. It is not hard to see why artists—like Wagner, or his English precursor William Blake—have been so captivated by this scene. It is, among other things, an

allegory for the power of art to arrest our attention and force us to question what we *think* we see. Perhaps the true significance of the impression in the dust was not ever meant for the crowd, or even us, to understand, but rather the woman herself. As the crowd disbands, Jesus looks up and asks innocently, "Woman, where are they? Has no one condemned you?" (John 8:10). She replies, "'No one, sir.' And Jesus said, 'Neither do I condemn you. Go your way, and from now on do not sin again'" (John 8:11). Surely Jesus already knows the answer to his question, yet by inviting the woman to answer he allows her the dignity of lifting her eyes and confirming for herself that no one stands above her, either physically or morally—something filmic renderings tend to neglect. Sight, perverted by false spectacle, has been repaired.

In the very next chapter of John, Jesus literally restores sight. Yet even here, in the case of the man born blind, not everything is as it appears. Throughout the story, binaries are introduced and inverted, from knowledge and ignorance to innocence and sin, and—above all—sight and blindness. The scene opens with Jesus walking along the road, almost like a chief resident doing grand rounds in a hospital. His disciples, playing the role of eager medical school students, ask him for his diagnosis, in the terms of the day. "Rabbi, who sinned, this man or his parents, that

he was born blind?" (John 9:2). Jesus refuses the terms of the question: "Neither this man nor his parents sinned; he was born blind so that God's works might be revealed in him" (John 9:3). While Jesus does not dispute his disciples' determinism—God still controls genealogy or genetics here—he mercifully undermines the equation of disability and immorality. Little does the man know, but his whole life has been leading him to this seemingly chance encounter.

Jesus spits into the ground, scoops up the resulting mud, slathers it on the blind man's eyes, then instructs him to wash away the dirt in the pool of Siloam (John 9:6–7). There's no practical reason, of course, that Jesus needs to go through this process in order to restore the man's sight. He could simply declare it so, as he does with some miracles. But what is at stake as much as anything is Jesus's creativity, and his self-dispensation to deploy it how and when he sees fit. (Seen through the later lens of rabbinic Judaism, Jesus's actions might be considered a trespass against the regulation to avoid undertaking *melachot*, creative works, during the Sabbath, specifically the act of *losh*, kneading or amalgamating substances.) Jesus's counterintuitive remedy for the blind man— "Here's mud in your eye," to quote a British toast—is

intentionally theatrical, while the rudimentary mate-
rials underscore his otherworldly powers. At the same
time, Jesus's instructions lead the man to participate in
his own healing, testing—and ultimately rewarding—his
belief in this strange man he has just met. It is as if Jesus
improvises a ritual on the spot, or, in the parlance of the
1960s art world, a "happening." One of history's great-
est works of performance art has been set in motion, it
seems, but only Jesus knows it.

When the man returns from the pool, sight restored,
his befuddled peers launch into an extended debate
about whether this is really the same man or some sort
of lookalike. The Pharisees, meanwhile—ever present on
the fringes in John's Gospel—launch a comedically inef-
fective investigation into the whole situation. As they try
to coax a helpful answer out of the formerly blind man,
he keeps proving Jesus's miracle. Seemingly at wit's end
with their bumbling queries, he declares, "Though I was
blind, now I see" (John 9:25), words that centuries later
would inspire the lyrics of "Amazing Grace." Much the
way he did with the woman accused of adultery, Jesus
concludes this episode with a question, which allows
the subaltern to speak, to borrow a phrase from theorist
Gayatri Spivak.

"Do you believe in the Son of Man?" He answered, "And who is he, sir? Tell me, so that I may believe in him." Jesus said to him, "You have seen him, and the one speaking with you is he." He said, "Lord, I believe." And he worshiped him. (John 9:35–38)

Ironically, it is the previously blind man—not the ostensibly perceptive religious experts—who truly *recognizes* the Savior in his midst. When we consider the fact that he was blind from birth, this scene is all the more incredible.

The situation recalls a famous thought experiment posed by the philosopher John Locke in the late seventeenth century: if a blind person, who could differentiate shapes by touch, was suddenly endowed with sight, could they discriminate between the same shapes by sight? Locke correctly theorized what we know today medically: the patient would suffer visual agnosia and only be able to connect visual and tactile information through extended experimentation. They might be able to see, but vision—the capacity to *understand* what we see—would take time. Read in this context, Jesus's words—"You have seen him, and the one speaking with you is he"—take on an added significance. He is quite literally teaching the man to see in this moment by cognitively connecting sound and sight, and—I would like

to imagine—touch. As this man begins to understand his new mind-bending reality, Jesus is literally at its center. True sight, one might say, is a matter of body, mind, and spirit working together.

SEEING THE LIGHT

So far, we have gleaned insights into how Jesus sees by considering what he says about visuality, and the interventions he stages when seeing goes awry. We will have ample opportunities in the ensuing chapters to talk more about how Jesus looked at the world around him and what this might say to our present circumstances. Before we do, though, there is another preliminary question to address, which bears directly upon sight. What would Jesus's contemporaries have seen when they looked *at him*? There are two ways we might tackle this question, one physical and the other metaphysical, and both are problematic for different reasons. When it comes to looks, neither the New Testament nor any other early sources offer us anything very specific or reliable to go on. It seems telling that Judas receives a stipend for identifying Jesus to the authorities with a kiss, a wholly unnecessary gesture if Jesus had any remarkable features (Mark 14:44–45). Many people today might swear they could pick Jesus out of a crowd,

but that is a testimony to the influence of artistic and cinematic representations of Jesus. There's nothing to suggest that the remarkably uniform—and we should add, *remarkably prejudiced*—image of Jesus as a modelesque, long-haired, faintly tanned white man brings us any closer to his representation in the Gospels. In fact, it mainly does the opposite.

In her aptly titled book *What Did Jesus Look Like?*, the New Testament scholar Joan Taylor brings a bracing dose of pragmatism to this issue. She argues,

> There is one quite obvious reason why Jesus in the Gospels was mentioned as neither particularly handsome, like a new Moses or David or angel, nor particularly unprepossessing, like the suffering servant of Isaiah 53: *he was neither*. He was ordinary-looking. There is a reason why no one particularly commented on the colour of his eyes, or hair, or skin: his were the same as just about everyone else's in the region: brown eyes, olive-brown skin, black hair . . . literally—his appearance was nothing to write home about.

While this assessment might seem to spell a dead end for her book, Taylor argues that the unremarkable

nature of Jesus's appearance ironically allows us to say more "because archaeology has enabled a much better understanding of the average man of Judaea in the first century." For our own purposes, which are more theological than historical, the probable banality of Jesus's appearance still offers useful lessons. Extreme beauty would have emphasized Jesus's transcendent godliness at the cost of his humanity, while deformity might have encouraged, even festishized, the pursuit of abjection. By not drawing attention to Jesus's appearance one way or the other, the Gospels suggest that what really stood out to Jesus's contemporaries—whether his enemies or acolytes—was the unique character of his teachings. Jesus was deeply concerned with looking, it seems safe to say, but not the least bit concerned with looking good.

If Jesus's physical features were unremarkable, what does it mean when he talks about himself in explicitly visual language? When he declares that he is "the light of the world"—as he does prominently in the Gospel of John (8:12; 9:5; cf. 12:46)—should we interpret that exclusively in metaphorical terms, as a statement of his theological luminosity? Not quite. John begins his Gospel by sketching a poetic cosmogony, in essence backdating Christ as Logos ("the Word") before "the beginning" of Genesis 1.

> In the beginning was the Word, and the Word was
> with God, and the Word was God. He was in the begin-
> ning with God. All things came into being through
> him, and without him not one thing came into being.
> What has come into being in him was life, and the
> life was the light of all people. The light shines in
> the darkness, and the darkness did not overcome
> it. (John 1:1–5)

John's rewriting of Creation cleverly plays with the imag-
ery of Genesis, which begins with the division between
light and dark. Moreover, we should remember, light is
the *sine qua non* for human sight, and so both Genesis 1
and John 1 are metanarratives about perception, among
many things. John's reshaping of Creation has particu-
larly profound and complex implications for Christol-
ogy, of course, which have been treated in extraordinary
depth by centuries of theologians. For our present pur-
poses, what's most important to note is that the Word is
both a cosmic force and a local light source, "coming into
the world" at a specific place and time (John 1:9).

So what happens to Christ's divine radiance upon
his Incarnation? How was it possible to suppress or
disguise this sublime effulgence over the course of his
human life? The New Testament does not provide any

clear answers, let alone describe how such a metaphysical dimmer switch might have worked. All we know, explains my colleague Ben Quash, is that Jesus somehow miraculously managed to bottle up this irradiating light, aside from one moment when "the lid came off briefly": the Transfiguration.

All three Synoptic Gospels—that is, Matthew, Mark, and Luke, so-called because of their similar point of view—treat the Transfiguration at length (John is strangely silent on the Transfiguration even though Jesus's radiant appearance would seem to reinforce his theology most of all). The Synoptics each offer slightly different accounts, but the key points are in harmony. Jesus takes three of his most trusted disciples and ascends a mountain, where "he was transfigured before them, and his face shone like the sun, and his clothes became dazzling white" (Matthew 17:2; cf. Mark 9:3; Luke 9:29) as he speaks to Moses and the prophet Elijah, two of the Hebrew Bible's most reliable character witnesses. Moreover, in Moses, Jesus meets a true peer, one whose own "face shone" after talking with God on Mount Sinai (Exodus 34:29). God then puts a final unambiguous stamp of approval on the scene, announcing from the heavens, "This is my Son, the Beloved; with him I am well pleased; listen to him!" (Matthew 17:5).

For his part, Luke even goes out of his way to tell us that the disciples "had stayed awake" for once (9:32), unlike their inopportune drowsiness at the Mount of Olives (Luke 22:45–46; cf. Matthew 26:36–46). The episode closes on a mysterious, even foreboding note. The two prophets disappear, and the disciples "kept silent and in those days told no one any of the things they had seen" (Luke 9:36).

The Transfiguration presents us with several interlocking paradoxes. On the one hand, it is presented as a key piece of evidence of Jesus's divinity, with God, the prophets, and the disciples all beholding and confirming his glory. On the other hand, the disciples keep everyone—including their comrades—in the dark about an event of earth-shattering significance. In a moment in which eyewitness testimony is crucial they are silent and secretive.

The next paradox bears specifically upon Jesus's appearance. As we noted above, Jesus's physical features seem to have been average to the point of inconspicuousness. Yet in this moment his noncorporeal nature, his divinity, is suddenly blindingly obvious to the naked eye. Physical sight beholds, and indeed vouchsafes, metaphysical reality. This is hardly how we are used to thinking of sight in the modern world, and yet it is perfectly in line with the way sight works in the Hebrew Bible, in which the

sublime regularly breaks into and reorders everyday existence in palpable, unmistakable ways.

The highly imagistic narration of the Transfiguration lends itself to representation, and it's no surprise the episode has been an enduring and popular motif in Christian art. While many of the great masters of Western art have treated the subject—including Raphael, for whom it constituted his final painting—perhaps the Transfiguration's greatest, and most influential, rendering has been in Eastern Orthodox icons. The Transfiguration is so crucial to Orthodox theology, in fact, that the "Uncreated Light" that issues from the Divine is often called the "Taboric Light," after Mount Tabor, where the event took place according to tradition.

The definitive representation of the Transfiguration is the life-size icon by Theophanes the Greek (figure 2), probably painted in the early fifteenth century and now held in the famous Tretyakov Gallery in Moscow. For those unaccustomed to the Orthodox tradition, and the sophisticated techniques and theology that underlie it, depicting "Uncreated Light" might seem insurmountable. But the conventions of iconography are uniquely suited to this challenge, and Theophanes (and probably his workshop) deploy them brilliantly. Jesus's garments have a purity that after centuries still feel "dazzling

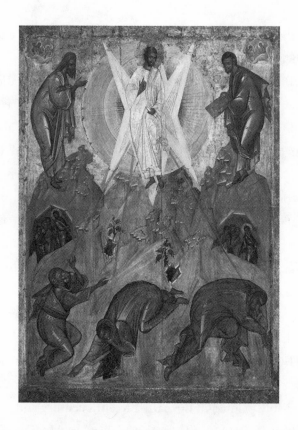

white, such as no one on earth could bleach them" (Mark 9:3). Using reverse, or Byzantine, perspective, Jesus not only levitates above the disciples, he seems to emanate out of the panel, entering into the viewer's space. Sacred geometry enhances the effect, with Jesus framed by acute intersecting triangles, set within concentric circles, recalling a pupil and iris. Rays of ethereal blue light beam

outward, striking the eyeballs of the disciples and pro-
pelling them to the bottom edge of the icon, almost like
an atomic blast. In telling contrast to the disciples, the
prophets Moses and Elijah look directly at Jesus from
the sides, without suffering these piercing vectors. They
behold him deferentially but from the same empyrean
plane, literally at eye level. Two kinds of sight—divine
and human—converge upon the figure of Christ, who
in turn looks out at us, into the three-dimensional space
of the present. The icon exquisitely clarifies the stakes
of the biblical text. Who sees—and, above all, who sees
God—is the exclusive purview of the Divine. God dic-
tates the conditions and limits of visibility, sometimes
lending human sight an otherworldly acuity, sometimes
leaving it hopelessly confounded, searching in darkness.

VANTAGE POINTS

In this chapter, we've seen that even some of the best-
known stories in the Gospels can yield fresh insights
about how Jesus saw his own world and how he might
see ours today. We began by focusing on the physical
aspects of sight, placing Jesus's statements about seeing
within philosophical and cultural context. Jesus cer-
tainly did not have a detailed, let alone modern, grasp of
anatomy or physiology. Nevertheless, Jesus understood

deeply what it *felt like* to see, in ways that are surprisingly contemporary. Most of all, he knew that sight is a dynamic embodied experience that impresses itself on us in tactile, tangible ways.

Jesus deployed this knowledge to great effect, choreographing scenarios meant to reshape his audiences' perspectives both as individuals and groups. He routinely engaged audiences in performative acts—sometimes without them even understanding what was happening—that inverted and recalibrated the power dynamics of sight. While Jesus's own looks appear to have been unremarkable according to the Gospels, when he let down his guard, his divine nature shined forth with searing clarity. Whether looking horizontally at the people around him or receiving a vertical blaze of light from above, Jesus always seems to be at the nexus of a powerful act of seeing. And the more we come eye to eye with him, the more we learn about sight itself.

PAYING ATTENTION

Pay attention!

Everyone has had the phrase yelled at them at one time or another, whether by a teacher, parent, pastor, or coach. For me, an ill-fated stint as an absent-minded left fielder comes to mind. Of course, it isn't just authority figures who demand attention, it is contemporary life itself. Myriad voices, in multiple keys, all constantly clamor for consideration.

In 2000, the political scientist Robert Putnam estimated that one of the greatest factors in America's steep decline in social capital—the glue that holds societies together and motivates collective action—was the luminous enemy within: television. Rather than gathering for clubs, games, charities, and church, Putnam found Americans were increasingly staying home, planted on the couch.

Putnam was writing in the relative infancy of the internet, before MySpace, let alone Facebook and Twitter, begat an explosion of social media usage in the ensuing decade. These days, one could argue, social

media is the greatest threat to social capital. It's hard not to roll one's eyes, for example, at the recent mission statement of Facebook (ahem, Meta): "Give people the power to build community and bring the world closer together." As sophisticated algorithms glean information about our interests and proclivities, silently steering us toward results, products, and groups, there's good reason to wonder how much our attention is really even ours anymore.

With little sense of irony, a bevy of apps have sprung up in recent years with the avowed purpose of helping us "find time," whether by playing soft music and meditation prompts or encouraging us to contemplate nature—on our screens, of course. There is even a video game that came out recently that encourages players to spend hours exploring a meticulous simulation of Henry David Thoreau's nineteenth-century retreat on Walden Pond in the Massachusetts woods. What does it mean, one might ask, to invite viewers to celebrate what Thoreau called his "newer testament,—the gospel according to this moment" by walking through a virtual forest, chopping virtual wood, and foraging for virtual berries? Perhaps this is a harbinger of a world to come, in which even our escape *from* technology at best leads us back into "open worlds" designed by coders. One thing is clear: we

are living in a time of increasingly more absorptive and addictive visual stimuli than in any other time in history, with the capacity to profoundly alter how we see both ourselves and others.

So how do we really *pay attention* as we get deeper into the twenty-first century? Too often, theological responses to this question are uninspired. There is a tendency to fall back on jeremiads against the modern (or postmodern) world, while pining for the way things used to be. While Jesus is frequently invoked in such laments, what he tells us about attentiveness in the Gospels is surprisingly relevant in a rapidly changing world. He certainly would not be uncritical of the habits and obsessions of the present, just as he offered piercing criticism of his own time. But the looking that Jesus challenges us to practice does not demand that we summarily reject or ignore the changes before us, or even *to* us. What he does require is that we look *with care*, an attention that is acute and empathetic in equal measure.

STAYING AWAKE

I wrote much of this book during the COVID-19 pandemic. Even for those on the more fortunate side of the ledger, this period was punctuated by sleepless, anxious nights. Would that we were all Charles Dickens, who put

his insomnia to good use, crisscrossing Victorian London in darkness, gathering stories. Instead, many of us found ourselves lying in bed, "doomscrolling" the latest news, awash in the icy blue emanations of phones and laptops (which of course only makes things worse!). When sleep came, it was often fitful. In fact, dentists reported a surge in fractured teeth, as people obsessively etched the stress of these days into their molars each night. Recalling such bleary-eyed days, it may seem curious—even a touch callous—to focus on staying awake. But as we will see, according to Jesus our underlying ailment is in fact our inability to stay awake, to focus our spiritual energies where they belong.

In chapter 1, we looked at the story of the Transfiguration, in which the disciples Peter, John, and James behold their master's dazzling appearance alongside the prophets Moses and Elijah (Matthew 17:1–8). Despite having witnessed Jesus crowned in glory on that field trip, the same trio of disciples proves maddeningly lethargic when Jesus takes them on another excursion, this time to the Garden of Gethsemane, at the foot of the Mount of Olives. Jesus has just informed his disciples that he will be betrayed by one among them, and predicted that all will deny him, though Peter vigorously protests. The stakes couldn't be higher, and yet Peter, John, and James

prove utterly unable to heed their teacher's words, laden with pathos: "I am deeply grieved, even to death; remain here, and stay awake with me" (Matthew 26:38).

The scene plays out three times, with percussive effect, and it is worth paying close attention to the increasing strain in Jesus's voice each time as his most trusted companions fail to honor his most basic request.

> And going a little farther, [Jesus] threw himself on the ground and prayed, "My Father, if it is possible, let this cup pass from me; yet not what I want but what you want." Then he came to the disciples and found them sleeping; and he said to Peter, "So, could you not stay awake with me one hour? Stay awake and pray that you may not come into the time of trial; the spirit indeed is willing, but the flesh is weak." Again he went away for the second time and prayed, "My Father, if this cannot pass unless I drink it, your will be done." Again he came and found them sleeping, for their eyes were heavy. So leaving them again, he went away and prayed for the third time, saying the same words. Then he came to the disciples and said to them, "Are you still sleeping and taking your rest? See [or, "behold"; Greek: *idou*], the hour is at hand, and the Son of Man is betrayed into

the hands of sinners. Get up, let us be going. See, my
betrayer is at hand." (Matthew 26:39–46)

The repetition in this scene, punctuated by the directive
to see or behold, lends it a palpable choreography: one
imagines Jesus exiting stage left, the spotlight falling
upon the sleeping disciples, and Jesus reentering stage
right to reenact the moment. The episode delivers a bit
of comic relief, with the behavior of the groggy disciples
interrupting the otherwise ominous crescendo leading to
Jesus's apprehension. And it is ironic, to say the least,
to discover that Peter—of whom Jesus has declared "on
this rock I will build my church" (Matthew 16:18)—can't
even stay awake past his bedtime! The scene ends on an
ominous note as Jesus twice directs his sluggish compan-
ions to "see" the danger right in front of them, as Judas
approaches with a party to arrest him.

The structure of the passage allows us to witness the
full arc of Jesus's emotions as he—truly, he alone—
comes to accept his fate. But the disciples' unreliability
introduces its own serious theological concerns. By suc-
cumbing to weariness, the disciples seem to demonstrate
a scandalous lack of faith in what Jesus has just proph-
esied. Would they really be so quick to nod off if they
truly believed the messiah would be led off to his doom

at any moment? There is a double sense to Jesus's words when he tells the disciples to pray that they don't "come into the time of trial." They will indeed face a time of trial, and they would do well to remain awake, for their own sake as much as their master's.

The disciples' greatest failure, to be sure, is one of empathy. They neglect to realize that the simple act of staying awake, being present, can in the most desolate moments constitute a powerful act of solidarity. It is the reason Jews sit *shiva* with the bereaved at their home, sitting on the floor or low furniture in alert, humbled commiseration. When Jesus reprimands Peter, calling the spirit "willing" but the flesh "weak," he is being generous, especially given the circumstances, since even the disciples' spirits don't seem all that willing. While Jesus prays to the Father to let the cup of suffering pass from his lips, all that he asks of his brothers is that they dilute his solitude. Matthew 26 is defined by iconic teaching moments. While Jesus uses the Last Supper to provide an enduring model of fellowship, he lets Gethsemane stand in powerful contradistinction. No cup is shared. No one pays attention.

While wakefulness is as an important act of esprit de corps, it must also be directed inward. In failing Jesus, the disciples also fail themselves, missing a crucial

moment—a last, brief pause in the accelerating tragedy of the Passion—to reflect upon *themselves*. Perhaps this is another reason Jesus is so disappointed in his disciples. He knows they will need rigorous self-discipline in the hard days, months, and years to come, as they spread his teachings to a disinterested and sometimes hostile world.

As Thomas Merton memorably put it, "The spiritual life is . . . first of all a matter of keeping awake." Drawing on his experience as a Trappist monk—in the aptly named Abbey of Gethsemani in Kentucky—Merton continues: "It is not really a paradox that it is precisely in meditation that most aspirants for religious perfection grow dull and fall asleep." Rather like the challenge of keeping mindful during Savasana (the corpse pose) in yoga, we require practice remaining still yet alert, quiet but present.

Christian tradition has accumulated numerous strategies for training and refining contemplative attention over the centuries. At Ireland's famous St. Patrick's Purgatory, located on a spartan island in the middle of a remote Irish lake, centuries of pilgrims were threatened with eternal damnation if they drifted off while fasting and praying through the night. More commonly, many Christians still observe the tradition of an Easter Vigil, keeping awake late into—if not always through—the

evening of Holy Saturday before Easter Sunday. In doing so, they symbolically keep faith with Jesus during his entombment, and in a sense do what the disciples were unable to do at Gethsemane. To me, the Easter Vigil recalls the tradition among Jews of staying up through the night studying Torah during the holiday of Shavuot. There's even a legend—rather reminiscent of the dozing disciples—that the Israelites slept in late on the morning God was set to deliver the law to them on Mount Sinai, and so Shavuot offers an opportunity to make up for our ancestors' tardiness.

This emphasis on attentiveness, and its myriad challenges, runs through non-Western religions as well. Buddhism, Hinduism, and Jainism are replete with stories that affirm the importance of mindful contemplation, and quite literally keeping one's eyes open. Perhaps none is more memorable than the story of the monk Bodhidharma, who transmitted Chan (Zen) Buddhism to China. He is said to have stared at a wall in meditation for nine years, and grew so frustrated when he lapsed into sleep that he cut off his eyelids (take that, Van Gogh!). According to legend, his eyelids fell to the ground and sprouted tea leaves, which monks harvested and brewed through the centuries to keep awake during their own meditations. We do not need to think of Jesus

as a Buddhist guru—though some writers have—to imagine he would have appreciated the reciprocal relation between attention and contemplation, wherever it is found.

How should one practice this type of attention, especially in an era that seems ever more designed to dissipate and distract us? As we've noted, there are many ritual practices, across various religious traditions, that offer spiritual wellsprings from which to replenish one's attention. But we must be careful not to assume that prayerful attention—"attention which is so full that the 'I' disappears," in the words of philosopher Simone Weil— must merely recapitulate tradition. "Extreme attention is what constitutes the creative faculty in man [*sic*]," writes Weil, "and the only extreme attention is religious."

Weil's insight, that spiritual attention can be imaginative and emancipatory, conveys a truth that artists have long appreciated. The Jewish painter Marc Chagall frequently declared, "When I paint, I pray," while his contemporary Henri Matisse called his mindset "close to that of prayer" as he created works including the Chapel of the Rosary in Vence, France. Keeping this kind of prayerful attention in mind, one might even wonder whether the disciples would've stayed awake in Gethsemane had they only taken to sketching! If this sounds a bit

fanciful, it's worth remembering that Christian tradition has long celebrated St. Luke as an artist, perhaps based on the remarkably attentive descriptions he provides in his Gospel. Indeed, Luke is often depicted painting portraits from life of the infant Jesus—as in Rogier van der Weyden's fifteenth-century masterpiece—even though he composed his texts well after Jesus's death. Whether one of the evangelists—or the disciples for that matter— was *really* an artist, thinking about artistic creation as a spiritual discipline offers an opportunity to enrich how we think about attention.

For my own part, I found myself returning to life drawing, after a gap of many years, when our son Arthur was born. In those early months, which often felt like a vigil, I found the sheer vulnerability of an infant rather terrifying. I envied my wife's incarnate knowledge of our son, which was joyously embellished by birth, not begun in that moment, as it was for me. Taking photos or videos of Arthur on my phone—however gratifying or indeed mandatory for grandparents—felt like an oddly detached, almost archival act. It was as if I was preparing for a future process of recollection without actually creating the memory itself. The technology interposed itself between us. Moreover, having lost my sister years before—her photos have become like relics to

me—even happy, casual snapshots of loved ones can feel suddenly precarious to me if I look too long; like fragments shored against a future loss, to adapt T. S. Eliot. Drawing, even in my amateurish way, offered something different for me. It was a compilation of sensations and feelings that turned nervous watchfulness into absorptive, active study. Unlike photography, drawing affirmed my son's solidity to me, not his fragility. Observing his wrinkly—and eventually, reassuringly chubby—contours was an embodied mode of knowing, one that could, in a small way, echo the way my wife understood our son. What Weil theorized, and what I think Jesus hoped for from his disciples, became clear to me through drawing: "Attention, taken to its highest degree, is the same thing as prayer. It presupposes faith and love."

KEEPING OUR DISTANCE

The kinds of attention we just looked at were intimate. They involved keeping close watch over a friend, a loved one, or indeed oneself. But how might we keep watch while also keeping our distance? How do we practice loving attention from afar? A few months into the pandemic, as it became clear to many that stringent social distancing would remain urgent for the foreseeable future, many commentators focused on the increasing

economic toll. In an insightful interview, Vivek Murthy, the United States surgeon general under Obama and again under Biden, offered a perspicacious warning about another type of downturn. The abrupt cessation of so many social connections, from schools to workplaces to family life, had the potential, he cautioned, to lead to a severe "social recession."

As Murthy noted, the pandemic exacerbated what was an already pervasive problem of loneliness in contemporary life. In recognition of this fact, the UK government appointed its first minister of loneliness in 2018, noting that as many as one in five Britons felt lonely much or most of the time, including tens of thousands of older people, who regularly go more than a month without seeing or speaking with a friend or family member. In 2021, the Japanese government appointed its own minister of loneliness, focusing on the plight of *hikikomori*, or social recluses, some of whom have been housebound for years after failing to land jobs during the country's last great recession. In the wake of prolonged isolation—whether a "preexisting condition" or catalyzed by the pandemic—social connections have to be consciously and carefully rebuilt, sociologists and psychologists suggest, and the process is not so intuitive or immediate as many might assume or hope. Nonetheless by drawing

discussions of loneliness into the mainstream, the pandemic has provided an opening to address the emotional, physiological—and, we must add, spiritual—effects of increasingly detached, technology-dependent lives.

Paradoxically, while the pandemic has revealed the costs of social isolation, it has also clarified the toll that unwanted contact can have. For some, the pandemic prompted a streamlining of their social landscape, or "friendscape," to use one researcher's cringey portmanteau. In a satirical take on such social curating, the late-night host Jimmy Kimmel suggested there's a simple litmus test: *real* friends are the ones you let use your bathroom during a pandemic! But more than simply compelling people to reevaluate their social priorities, the pandemic also clarified the intense burden physical contact can place on some people.

In 2020, a number of journalists explored how women's experiences, especially in urban settings, changed during the pandemic, including a welcome relief from the near-constant, and too often normalized, touches of men. The pandemic also offered a reprieve for many neurodiverse individuals, for whom even friendly physical touch from trusted individuals, such as handshakes or hugs, can be unwelcome (e.g., certain types of autism) or downright physically and emotionally painful (e.g.,

haphephobia). Post-COVID, a more candid discussion about the positive effects of social proximity and physical touch must also take into account the experiences of these varied communities rather than uncritically "embracing" a return to normal.

While the terms above would certainly be unknown to Jesus, the complexities of social and sensory distance are at the very core of his ministry. Throughout the Gospels, Jesus deliberately seeks out those from whom his society sought to distance, at times even barricade, itself. He keeps company—*close* company—with those who are socially disdained, including unattached or accused women, as we noted earlier. He heals those thought to be cursed, impure, severely contagious, or possessed (a tragic misconception of the mentally ill according to many modern commentators). Nor does Jesus seem to fear the company of the dead, as we find when he revives the reeking, four-day-old corpse of Lazarus (John 11:39).

Without a doubt, in the time of COVID-19, Jesus would have sought out and surrounded himself with people in unsafe factories and stores, ill-equipped hospitals and nursing homes, overcrowded prisons, and mobile morgues. And no one would have been subject to more withering critique by Jesus than the politicians and pundits who cynically ignored or belittled the

catastrophe from atop their antiseptic towers. Still, as much as he sought the company of the disenfranchised, Jesus's empathy and attention were not without limits. The Gospels, especially the Synoptics, are replete with stories of Jesus being physically, emotionally, and spiritually drained by the scores of people who followed him from town to town, desperately seeking his attention. Rather than constant and impervious, his supernatural powers seem to dissipate from overstimulation, and have to be continually replenished by withdrawing into quiet, isolated meditation. With a pathos that only makes him more approachable, Jesus's attentiveness, his ability to absorb the suffering of others, leaves him depleted.

Throughout the Synoptics—John tends to shy away from such displays of vulnerability—Jesus withdraws to the wilderness to recuperate his physical and spiritual strength. In the very first chapter of Mark, we already find Jesus hard at work curing the sick and casting out demons, and at Capernaum "the whole city was gathered" to observe his miraculous deeds (Mark 1:33). Jesus indulges the crowd, like a rock star signing autographs until everyone has left the arena, but it seems to take its toll.

> In the morning, while it was still very dark, he got
> up and went out to a deserted place, and there he

prayed. And Simon and his companions hunted for him. When they found him, they said to him, "Everyone is searching for you." He answered, "Let us go on to the neighboring towns, so that I may proclaim the message there also; for that is what I came out to do." (Mark 1:35–38)

As the biblical scholar Jonathan Homrighausen notices, "Jesus takes advantage of nighttime, the lack of sight, to leave—and pray—for spiritual sight." Jesus not only seems to give himself space, but deliberately makes himself hard to find, although commentators have offered a wide range of interpretations of this scene. The disciples prod him to return, and in the NRSV translation one can almost hear him sigh as he summons the strength to do "what I came out to do."

The same pattern repeats itself in Luke, where Jesus heals the sick before crowds, and then "would withdraw to deserted places and pray" (Luke 5:16). Whenever possible, it seems that he preferred to hike up hillsides or mountains, where he would pray through the night (Luke 6:12), finding clarity in the darkness. After particularly exhausting miracles, like feeding the five thousand with loaves and fishes, Jesus needs distance not only from the crowd, but even his closest companions. Matthew tells

us, "Immediately he made the disciples get into the boat and go on ahead to the other side, while he dismissed the crowds. And after he had dismissed the crowds, he went up the mountain by himself to pray. When evening came, he was there alone" (Matthew 14:22–23).

Tellingly, Jesus acknowledges that his disciples, in their own way, must also be enervated from "all that they had done and taught," and he insists at one point on a group retreat, saying, "Come away to a deserted place all by yourselves and rest a while" (Mark 6:31). In the end, Jesus's compassion for the people, whom he finds "like sheep without a shepherd," always lures him back to his life of service (Mark 6:34). But as these episodes accrue, and the crowds and their demands proliferate, it becomes almost painful to watch Jesus expend every last drop of energy, as many artists, filmmakers, and writers have captured. Well before he is pinned to the cross, Jesus has already begun to sacrifice his body for his flock.

While Jesus is defined by his selflessness, his instincts for self-care, as we would call it today, are surprisingly contemporary. He understands intuitively that he needs to pull away from the smothering gaze of the throngs who follow him and seek relief in the environment. In fact, recent psychological research has demonstrated the

restorative power of exposure to nature in various ways. One study revealed that the very same physical activity pursued amid vegetation outdoors instead of indoors—sorry, Peloton—enhances the physiological benefits of the activity in ways that further reduce stress. Another study focused specifically on the benefits of "awe walks" for seniors, and found that those who practiced looking with fresh eyes and wonder at the world around them experienced greater mental health benefits than the control group. Both groups were asked to take a quick selfie on their walk to record their location, and researchers were intrigued to find that the awe walkers' photos focused less on themselves over time and more on the beauty of the world around them. It's no wonder that the Japanese practice of "forest bathing," or contemplative walking, has become so popular as a counterbalance to urban life. Even in a less than lush landscape—say from a mountaintop in Judea—looking at the natural world can induce a calming effect on the parasympathetic nervous system. Rachel Kaplan and Stephen Kaplan emphasize how the kind of gentle, roving gaze we cast over a natural vista—"non-directed attention"—can help recharge our capacity for "directed attention," whether that means healing the masses like Jesus or staring at a computer screen, like I'm doing right now.

The fact that Jesus repeatedly withdraws into nature by night is not simply convenient, it is itself a strategy for replenishment. While Western culture has often cast the night as a time of unsettlement, danger, or even outright evil, nighttime can also be generative and sustaining. The Hebrew Bible contains numerous examples of the night's revelatory, often highly visual, potency. While sleeping on the bare ground, beneath an open sky, Jacob dreams of a ladder—or staircase, depending on the translation—upon which "the angels of God were ascending and descending" (Genesis 28:12). When he wakes, still shaken by this sublime sight, he exclaims, "How awesome is this place! This is none other than the house of God, and this is the gate of heaven" (Genesis 28:17). Just a few chapters later, Jacob's nocturnal visions take a fleshly turn. He wrestles the entire night with an angelic figure, who finally declares, "Let me go, for the day is breaking" (Genesis 32:26). The angel's presence, it seems, is only made possible—or indeed tolerable—by the cloak of darkness. After extracting a blessing from the angel, Jacob limps away, declaring, "I have seen God face to face, and yet my life is preserved" (Genesis 32:30).

The German novelist Thomas Mann memorably explores the fecundity of darkness in his epic series of biblical novels, *Joseph and His Brothers*. For Mann, the

grandeur of the biblical night sky serves as a leitmotif, echoing and nourishing the spiritual potency of the patriarchs. While narrating a conversation between Jacob and Joseph, he pauses to offer one of many paeans to the firmament:

> As they spoke the moon, its shimmering light so pure that it transfigured its own materiality, had continued its high journey; the position of the stars had changed according to the law of hours. Night wove peace, mystery, and the future out into far expanses.

Mann's vision of the ancient heavens, uncompromised by electrification and rampant light pollution, would have been Jesus's reality. Unlike our world, in which unadulterated darkness is so precious it is charted, conserved, and certified around the globe by the International Dark-Sky Association, Jesus would have enjoyed a nocturnal world of dazzling distinctions, no less miraculous for being available to everyone.

The natural world not only allows Jesus the space to replenish his attention, it refocuses it on the transcendent. Jesus is hardly alone in seeking the divine on higher ground. And it's no coincidence, as we saw in

chapter 1, that in the transfiguration he meets Moses on a mountain (Mount Tabor according to tradition), echoing the revelation at Mount Sinai. The spiritual significance of mountains is well attested across religions, from Mount Fuji for Shinto and Buddhist practitioners in Japan to Mount Katahdin for the Penobscot people in my home state of Maine. One might even consider adding through-hikers, for whom Katahdin marks the culmination of months spent on the Appalachian Trail, its own pilgrimage of sorts. As the phenomenologist Mircea Eliade notes, every community tends to claim its own high ground as an *axis mundi*, a sort of cosmic pillar linking heaven and earth, in effect locating ourselves at the center of our universe. As he seeks to commune with God and recover his equilibrium, Jesus stakes out his own such axis, or indeed becomes one himself.

In his pursuit of silence, Jesus gravitates toward the most distant, dark, and elevated spaces he can find, in an ancient land replete with wilderness. But just how accessible is this kind of isolation in modern life? Even in the mid-nineteenth century, from his privileged retreat on Walden Pond, Thoreau keenly sensed the encroachment of modernity, insistently tugging at his attention. He writes:

I am alarmed when it happens that I have walked a
mile into the woods bodily, without getting there in
spirit. . . . The thought of some work will run in my
head and I am not where my body is,—I am out of my
senses. . . . What business have I in the woods, if I am
thinking of something out of the woods? I suspect
myself, and cannot help a shudder, when I find myself
so implicated even in what are called good works.

Thoreau invokes a classic Christian theological distinc-
tion here between "good works" and grace, traditionally
understood as the unearned—in fact, unearnable—gift
that Christ bestows on the faithful. For Thoreau, nature
itself bathes believers in grace, yet only if one can be
truly present in both body and spirit. Even more than
the depredations of industrialization, the primary hur-
dle we face, according to Thoreau, is our own spiritual
inattentiveness.

What Thoreau obscures, of course, is that access to
nature can be brutally unequal. Communities of color—
including vast numbers of Native Americans in Thoreau's
day—have been repeatedly driven off lands coveted for
their beauty or natural resources. And as Dina Gilio-
Whitaker, Dorceta Taylor, and other scholars of envi-
ronmental justice remind us, marginalized peoples today

WHAT WOULD JESUS SEE?

continue to be pushed into areas in which the environment is hazardous or downright toxic. At the most basic level, even the opportunity to seek respite under shady trees along hot city streets, or contemplate the stars despite light and air pollution, are rarified commodities, available only to denizens of certain postal codes. When I lived in the Washington, DC area, for instance, my own leafy community had a measurably better temperature, air pollution index, and pollinator population than communities mere miles away, especially south of the Anacostia River. Any celebration of the spiritual replenishment individuals might seek out in nature must be accompanied by an urgent effort to secure this privilege for all. Tellingly, even when we study Jesus's rare moments of self-care, it seems, he guides us down a path that calls our attention to others.

HIGH ALERT

In the beginning of this chapter, we looked at just how hard it can be to pay attention in our overstimulating, digitally driven world. We then used scriptural examples to home in on two key problems: how to stay awake and how to replenish our concentration. These explorations led us to identify forms of spiritual discipline we can cultivate to meet these challenges, from creative

observation to immersion in nature. This focus on art and nature offered opportunities to draw in multiple—including multifaith—perspectives. As we conclude this chapter, we will change tenses as well as perspectives. In this section, we'll look at how Jesus teaches his followers to remain "in the moment" not only for its own sake, but for the sake of what is to come. There are myriad ways to interpret Jesus's eschatological vision—including precisely what role he envisioned for himself in this divinely ordained future—but Jesus clearly believed himself to be living on the precipice of a new world.

Jesus was hardly the only charismatic Jewish leader of his day to predict or become the focus of fervent messianic hopes, which for Jews of the time meant, first and foremost, the reestablishment of Jewish hegemony in the Holy Land. A century after Jesus's death, for instance, the Jewish military leader Simon Bar Kokhba would lead a revolt against the Roman occupation that was so successful initially that the great Rabbi Akiva considered him the Messiah. Unlike such ancient peers, however, Jesus's eschatological vision remains a world-altering force today, shaping our twenty-first century in dramatic ways.

Our inquiry into "what Jesus would see" would be incomplete without asking what this apocalyptic mindset

might teach us. There are innumerable theologians—let alone saints—whom readers can consult about what this vision entails for Christian believers and how it should guide their lives. My own animating question is less expansive and certainly less orthodox: What can Jesus's apocalyptic outlook teach us *apart* from its salvific content? Regardless of whether one believes Jesus's vision of the future will come to pass, I would suggest that it might train us to look at our world in useful ways that traditional Christian approaches might miss (for good reason).

Jesus's teachings can seem downright cryptic, not only to his contemporaries but to those of us reading them today. Yet when Jesus discusses the Day of Judgment, he often lifts the veil, seemingly desperate for his listeners to understand the stakes of what he is saying. "Be dressed for action," he tells a crowd (Luke 12:35). Be like the servants who stay awake all night waiting for their master to come home, ready to receive him, Jesus says, and you will gain unexpected riches (Luke 12:36–38). Then, switching metaphors on a dime, Jesus compares the coming of the messiah to a thief in the night. "You also must be ready," he explains, "for the Son of Man is coming at an unexpected hour" (Luke 12:40). The same message appears in the parable of the virgins (or

bridesmaids) waiting for the bridegroom to arrive for the wedding feast, who stock extra oil and trim the wicks of their lamps in preparation (Matthew 25:1–13): an image ominously evoked by Johnny Cash in his apocalyptic song "The Man Comes Around."

As Jesus's destiny draws him closer to the cross, his warnings become ever more clarion, and he lets his extended metaphors drop away, leaving only an urgent, unvarnished plea to his followers.

> Truly I tell you, this generation will not pass away until all things have taken place. Heaven and earth will pass away, but my words will not pass away. Be on guard so that your hearts are not weighed down with dissipation and drunkenness and the worries of this life, and that day does not catch you unexpectedly, like a trap. For it will come upon all who live on the face of the whole earth. Be alert at all times, praying that you may have the strength to escape all these things that will take place, and to stand before the Son of Man. (Luke 21:32–36)

According to Jesus's prophetic vision, the coming of the end times will be at once imminent, instantaneous, and unexpected. As such, what Jesus demands is not some

esoteric capacity to read the tea leaves but a state of hypervigilance, focused on events unfolding in the real world, blindingly clear for those with eyes to see.

How practical is it, though, to remain in a state of perpetual alert? Apocalyptic fervor rarely remains constant in religions over time, tending instead to crest and fall due to various factors, from the emergence of charismatic leaders and signs of abstruse prophecies to societal factors including economic insecurity and conflict. Sometimes these apocalyptic affairs are over embarrassingly quickly. In Jewish history, the great upheavals and persecutions of the early modern period proved conducive to the emergence of Sabbatai Zevi, a mystic who preached the coming of a new era in which Jewish ritual law could be freely abrogated and the Holy Land would again be under Jewish rule. Zevi was so convincing that Jews across Europe and the Middle East sold all their earthly belongings and followed him, until it all came unraveled when their messiah reached Constantinople and converted to Islam!

Lest we feel too superior, our twenty-first century has already proved a golden age for millenarian fantasies. First, the two-thousandth anniversary of Christ's birth coincided with fears about a devastating Y2K computer glitch, then came predictions of a 2012 apocalypse

based on misinterpretations of the ancient Mayan calendar. And, lately, QAnon has conjured a bizarre cocktail of political paranoia, white supremacy, and new-age occultism focused on Donald Trump as an unlikely savior destined to lead a "Great Awakening." However brightly and dangerously such apocalyptic fires burn, however, there is every reason to suspect they will eventually flame out, even as internet trolls gather kindling for future conspiracies.

Our incapacity to sustain indefinite alarm is no less evident even when we approach more rational, proximate threats. After 9/11 in the United States and the 7/7 bombings in the United Kingdom, both countries adopted a full spectrum of threat levels that nonetheless hovered constantly between high and extra high. The predictable effect of course was that most people became simply inured to such warnings despite—or indeed because of—their unceasing severity.

A similar dynamic has replayed itself in the face of the existential challenge of climate change, even as its effects become more visible and constant, from superstorms to megadroughts. The veteran climate campaigner George Marshall draws on Nobel Prize winner Daniel Kahneman's *Thinking, Fast and Slow* to analyze why we stubbornly refuse to act upon such an

overwhelming threat. The sheer scope of the problem, the kind of abstract thinking it takes to grasp it, and the long, multifaceted approaches it demands run counter to many of the ways in which we are biologically and culturally conditioned to perceive and act upon threats. Our cognitive skillset, it seems, may be uniquely ill-adapted to the present epoch, in which competing apocalypses—from the absurd to the exigent—all clamor for attention. Rather than remaining in a state of fear and trembling, it's tempting to croon along with R.E.M.: "It's the end of the world as we know it, and I feel fine."

In a world so saturated with catastrophic rhetoric and imagery it's reasonable to wonder just what distinguishes Jesus's apocalyptic outlook and makes it worth tuning in to. While Jesus's warnings can be dire, his eschatology is suffused by an abiding and accessible hope. And it is this hope that makes it both sustainable and constructive. The virgins who fail to trim their wicks, or the negligent servants, may be in for a rude awakening, but those who stay prepared for the coming of their master are promised a banquet like no other. It has become commonplace, even reflexive, these days to dismiss hope as dewy-eyed optimism. When Barack Obama ran for president in 2008, it didn't take long, for example, for Sarah Palin to cynically (and ungrammatically) rebrand

his message as "that hopey, changey stuff," as if believing in a better future was somehow embarrassing. Yet hope can be profoundly serious and—just as importantly— eminently realistic.

The theologian Jürgen Moltmann, writing in the wake of the Second World War, in which he was conscripted as a German soldier, offers a powerful defense of hope. Rather than being evasive, Moltmann insists that genuine hope is able to meet the world at its nadir, its bleakest point, and still assert a compelling countervision. He writes:

> Thus hope and anticipations of the future are not a transfiguring glow superimposed upon a darkened existence, but are realistic ways of perceiving the scope of our real possibilities. . . . Hope and the kind of thinking that goes with it consequently cannot submit to the reproach of being utopian, for they do not strive after things that have "no place" [the literal meaning of utopia], but after things that have 'no place *as yet*' but can acquire one.

Moltmann is writing here specifically in defense of Christian eschatology, which, as he makes clear, "speaks of Jesus Christ and *his* future." Yet Moltmann's

celebration of the power of the eschatological imagination is not applicable exclusively to Christians. The creative "passion for the possible" recognized by Moltmann in Christian hope may still be glimpsed, admired, and even emulated by those who engage with Jesus's vision from beyond the precincts of belief. Jesus reminds us not only that hope is serious business, but that a future that is feared but not longed for will fail to hold our attention, however high the stakes.

Still, we should be careful not to discount the element of dread in Jesus's eschatology. If hope, as we saw, is too often brushed aside as mere naivete, doom can be just as easily written off as antiquated fire and brimstone, an embarrassing excess of pious sincerity. Yet even for those who do not fear the coming of the Son of Man promised by Jesus, the specter of irrevocable judgment can remain instructive. Jesus's eschatology invites us to imagine, in vivid terms, what would happen if the clock were to stop suddenly on the world as we know it. Like a game of musical chairs, where would we be left standing, and how would we justify ourselves and our actions in that moment?

The uncertain hour of judgment preached by Jesus transcends conventional notions of fairness. It happens not when we wish for it, or are most prepared to receive

it, but at the gratuitous will of the divine, which may well appear capricious or even cruel by human calibrations. Imagining our own dramatic end—even if we don't hold to it as an article of faith—can catalyze a sense of extreme personal and collective responsibility for the present. Faced with overwhelming threats like climate change, such radical responsibility can be a precious resource if carefully deployed, with the right admixture of hope and horror.

It's hard to imagine Jesus would be very impressed by our eschatological acuity these days, especially when it comes to climate change. Luke tells us,

> [Jesus] said to the crowds, "When you see a cloud rising in the west, you immediately say, 'It is going to rain'; and so it happens. And when you see the south wind blowing, you say, 'There will be scorching heat'; and it happens. You hypocrites! You know how to interpret the appearance of earth and sky, but why do you not know how to interpret the present time?" (Luke 12:54–56)

Jesus takes it as self-evident that his audience trusts the evidence of their own eyes and can deduce basic meteorological outcomes from the natural world. In a land

dependent on agriculture, he assumes only fools would be so daft as to shut their eyes to beacons of incipient rain or sun, cold or heat. Yet even as the effects of long-term climate change have become brutally apparent in our weather—as I write this, for instance, California wildfires are burning so intensely they're releasing pillars of smoke visible from space—many still refuse to "interpret the appearance of earth and sky," as Jesus puts it. And, in doing so, they also refuse "to interpret the present time."

We are hypocrites in a way Jesus could scarcely have imagined: unable to recognize an unfolding apocalypse not just as obvious *as* the weather but actually manifested *in* the weather! As environmental journalist and activist Bill McKibben strives to make clear to Christian audiences, we are living in an unfolding catastrophe of literally biblical scope. In the book of Job, which McKibben calls "the first great piece of nature writing in the Western tradition," God recounts to Job his magisterial control over the elements themselves. "The more I learned about the greenhouse effect," McKibben explains, "the more I realized that God's unanswerable taunts to Job were suddenly—in my lifetime—turning into the empty boasts of an old geezer." We are in the paradoxical position of being capable of conjuring apocalypses on a

sublime scale yet unwilling to take even small actions to avert them. Thinking eschatologically, as Jesus encourages us to do, doesn't demand something new so much as recovering a skill we've let lapse: the ability to see the future in the present, for both better and worse.

VANTAGE POINTS

We've looked at various forms of attention in this chapter. In each section, we've explored different ways of conceptualizing what it might mean to be "in the moment." Using Jesus's teachings, interactions, and habits as our starting points, our aim—not unlike Jesus's nighttime walks—has been to head into unfamiliar territory, where we could gain a new vantage point. In doing so we've consciously moved away from how this terminology often appears in popular culture. Being "in the moment" has become a central tenet in the cult of self-actualization, a cultural shorthand for blocking out the needs, demands, or even gaze of others, which might cloud one's own goals or experiences.

The pervasiveness of this construction struck me during the pandemic when, in the absence of live sports, I nostalgically binge-watched every episode of *The Last Dance*. The documentary—or indeed hagiography—chronicles Michael Jordan's final season with the Chicago Bulls. In

an effort to explain just what separated Jordan's notoriously competitive mindset from his peers, one commentator spoke reverentially about the superstar's "mystic" ability to remain in the moment, to *not see* the possibility of failure. Jordan's monomaniacal focus has been celebrated as a paradigm of greatness by commentators, coaches, and sports psychologists for more than a generation. Indeed it's really only in recent years, epitomized by the bravery of tennis star Naomi Osaka and gymnast Simone Biles, who openly prioritized their mental health above sporting triumph, that this discourse has begun to shift.

The problem with Jordan's model of concentration is not that it's ineffective, but that it's *so* effective, at least in terms of competitive outcome. It raises self-belief to an almost stratospheric level—if His Airness will excuse the pun—which can be difficult to constrain to the arena, and potentially prove self-destructive out of it. When we lift up such models, which we so often do with sports stars—think of Gatorade's classic "Be like Mike" ad campaign—we run the risk of normalizing and generalizing a very specific mode of attention. If we're not careful, being "in the moment" can come to mean little more than being absorbed in the self. Nothing could be further, of course, from what Jesus had in

mind. While the forms of attention we examined in this chapter each encourage us to be "in the moment" in different ways, they do so by opening our eyes to what lies *beyond* the self.

The Catholic priest and theologian Henri Nouwen explains this delicate balance between self-awareness and selflessness beautifully in *The Wounded Healer*. Nouwen suggests that true, open-hearted care for others, not directed at gaining something from them or gratifying one's own desires, first requires self-reflection.

> Anyone who wants to pay attention without intention has to be at home in his own house—that is, he has to discover the center of his life in his own heart. Concentration, which leads to meditation and contemplation, is therefore the necessary precondition for true hospitality. . . . Paradoxically, by withdrawing into ourselves, not out of self-pity but out of humility, we create the space for another to be himself and to come to us on his own terms.

To return to our earlier terminology with the benefit of Nouwen's wisdom, being "in the moment" in the right way fosters a self-awareness that leads naturally into the company and service of others. It is for this reason, as

we saw in this chapter, that Jesus retreats into the wilderness: not to escape society but rather to restore himself, so that he might resume his journey of self-sacrifice. Seeing, as we observed in this chapter, is no small part of this process for Jesus. And it is worth exploring how we too may find looking outward conducive to looking inward. Whether it is to the page of a sketchbook, a forest clearing, or a storm gathering on the horizon, even modest acts of attention may stir deep spiritual insights.

It's the golden age of silver tongues. There's never been a time when it's been easier or quicker to spread half-truths, untruths, and flat-out lies across the globe. A single Twitter binge by a celebrity or politician (or, worse yet, one who's both) can provide a toxic feast of disinformation for internet trolls to disseminate ad nauseam.

At times, satire seems to be the only way to make sense of this mess. In 2005, in the pilot episode of *The Colbert Report*, the comedian Stephen Colbert introduced us to the word *truthiness*, in retrospect the very epitome of the postfactual era. In a brilliant parody of the talking heads of twenty-four cable news channels, he opined, "The Truthiness is anyone can read the news to you. I promise to *feel* the news at you." Colbert's neologism eventually even made it into the *Oxford English Dictionary*. With perfect pitch, the *OED* soberly notes that "truthiness," in the Colbertian sense, is only the second meaning of the word. The first: "Truthfulness. Now *rare*."

Colbert's tongue-in-cheek oath to "*feel* the news" at his viewers succinctly identified two fundamental aspects of the media culture of that moment, which would become supercharged by social media. First, facts are visceral things, to be sensed rather than discovered or deduced. Secondly, they should come prechewed for passive consumption. These qualities are now overtly embraced by a range of media outlets around the world, especially—though certainly not exclusively—on the right wing.

The political philosopher Hannah Arendt saw this coming. Arendt might as well have been watching a primetime feed of Fox News when she wrote in 1967,

> The liar, lacking the power to make his falsehood stick, does not insist on the gospel truth of his statement but pretends that this is his "opinion," to which he claims his constitutional right. . . . In a politically immature public the resulting confusion can be considerable.

As Arendt goes on to demonstrate, this form of lying, as craven as it is, may simply be a milestone on the way to an even steeper moral and civic decline. Down the road, this confusion between fact and opinion leads

to a disorienting landscape in which truth is not only obscured but irrelevant. According to Arendt,

> the surest long-term result of brainwashing is a peculiar kind of cynicism—an absolute refusal to believe in the truth of anything, no matter how well this truth may be established. In other words, the result of a consistent and total substitution of lies for factual truth is not that the lies will now be accepted as truth, and the truth be defamed as lies, but that the sense by which we take our bearings in the real world—and the category of truth vs. false-hood is among the mental means to this end—is being destroyed.

If lies were merely the opposite of truth, one could simply reverse course, so to speak, and still navigate back to the facts. But in the political landscape envisioned by Arendt—which threatens to become the prevailing reality of the present—true north no longer exists.

While mendacity creates the contours of this topography, eroding truth until it disappears, images lend this *fata morgana* its texture and color, making it both desirable and believable. Arendt recognizes the potential complicity of images, but they aren't her focus. To elaborate

her argument, it's helpful to turn to Susan Sontag, who shares Arendt's concern with how images, especially photographs, come to substitute for reality. "The powers of photography," argues Sontag, made it "less and less plausible to reflect upon our experience according to the distinction between images and things, between copies and originals." While we're used to thinking we're witnessing reality or truth when we look at a photograph, Sontag reminds us that we are seeing an *image*, which only *feels* real. In a world already saturated by images, this comes to seem natural. And that, Sontag notes, is precisely the problem. Given this extraordinary slipperiness, it's not difficult to see why Arendt was so wary of images being enlisted in political deception. One can only imagine what Arendt or Sontag would make of the Pandora's box opened by deepfakes and other contemporary technologies, which makes photographic chicanery look like child's play.

At a time when truthiness overrunneth, what hope do we have of recognizing the *actual* truth? And, to return to our familiar question, what help might Jesus offer us? Jesus certainly didn't have to contend with a hypermediated reality like ours. Yet, as we will see, he was obsessed with unmasking the deepfakes of his own time, from displays of false piety to people bearing false witness to

the appearance of false messiahs. As usual I am less concerned here with the more overt theological claims made by and for Jesus, who succinctly declares himself "the way, and the truth, and the life" (John 14:6). Christians know this Jesus well already through scripture, tradition, and personal experience. What I want to look at is how Jesus *sees* the distinction between truth and falsity, and what tools he offers for discerning the difference.

I use the term *discernment* deliberately, as it summons connotations of both visual and spiritual cultivation. We often say someone has a "discerning eye," such as a curator trained to spot a forgery or recognize an unknown talent. But we also talk about people discerning spiritual truths. In Catholic tradition, discernment is a major touchstone for the Society of Jesus, or Jesuits. St. Ignatius, the order's founder, was highly visually attuned, as one discovers often in his *Spiritual Exercises.* He believed in a regular practice of taking stock, looking inward to discern how one had either drawn closer to or further away from God's love over the course of a day. "In the act of discerning love, Ignatius saw the epitome of the Christian imitation of Christ." Discernment is also often used in the context of exploring a vocation or religious calling. Anglicans and Episcopalians, for example, refer to a "discernment process" by which candidates for

theological training and ordination are assessed. What both the artistic and theological uses of the word share is a sense that discernment is something difficult and rigorous. It takes work. And repetition.

In this chapter, we'll delve into how Jesus embodies this approach and attempts to teach it—though not always with success—to those closest to him. As we seek out contemporary parallels, we will find that politics is rarely far from sight. Truth itself may not be political but revealing it often is. To return to Arendt once more: "Where everybody lies about everything of importance, the truthteller, whether he knows it or not, has begun to act; he, too, has engaged himself in political business, for, in the unlikely event that he survives, he has made a start toward changing the world."

FALSE APPEARANCES

Jesus was well aware of the perils of misrepresentation. Word spread quickly through the ancient Palestinian countryside of his activities, especially his miracles. And from the early days of ministry onward, rumors seemed to keep one step ahead of him as he moved from town to town. Perhaps because of this personal experience, Jesus was especially sensitive to the risks of performing religious acts in public. Even when it comes to simple

acts of devotion like fasting or giving alms, Jesus warns against attention overtaking intention. "Beware of practicing your piety before others in order to be seen by them" (Matthew 6:1), he reminds listeners. "And whenever you fast, do not look dismal, like the hypocrites, for they disfigure their faces so as to show others that they are fasting" (Matthew 6:16). Even asceticism, the very practice of self-denial, can become a competition, falsely burnishing one's sense of ego. Later, as Jesus attempts to drive this point home, he delivers a graphic polemic, calculated to play with listeners' ideas of ritual purity. "Woe to you, scribes and Pharisees, hypocrites!" cries Jesus. "For you are like whitewashed tombs, which on the outside look beautiful, but inside they are full of the bones of the dead and of all kinds of filth" (Matthew 23:27). The appearance of piety, Jesus argues, may not only be misleading, but negatively correlated to actual virtue. The more perfectly we polish our façade, the more we neglect what's buried behind it.

Tellingly, while Jesus castigates affectation, he does not ignore the value of visuality full stop. Instead, he redirects it in subtle ways. The person who fasts shouldn't "look dismal," even if they are in discomfort, as they should be for the sacrifice to be meaningful. Paradoxically, not calling attention to one's act of piety might

actually require an element of artifice or misrepresentation. Some misrepresentation—provided it's directed at deflecting undue praise—might be a good thing. Jesus gives his listeners the tools to see through false displays with searing clarity. But he is aware that self-representation requires a more complex calculus, taking into account not only what *is* true, but what will *appear* true to society.

Traversing this kind of representational terrain has never been easy, but the proliferation of social media has certainly added new pitfalls. It's a safe bet, for instance—despite many marble sculptures to the contrary—that most Roman rulers didn't really look like Apollo. Social media, however, delivers the tools and fruits of artifice to a previously unthinkable number of people, with the lowest possible bar of admission. Moreover, the very algorithmic structure of social media means that it rewards, and indeed monetizes, deceptive self-representation. "Influencers" on Instagram and other platforms build mass followings through highly curated and filtered images of glamorous lifestyles, which they may or may not be actually living (which may or may not matter to consumers). And this in turn generates endorsement deals for further products and experiences that they incorporate into their ever-evolving online mythology.

In the glossy, decontextualized images that proliferate across social media profiles, the "whitewashed" façades decried by Jesus come to life in an eerie new way. If anything, these fabrications are even more disturbing, for rather than Pharisaical acts of piety, they turn privilege—and white privilege above all—into its own virtue. Even acts of ostensible self-discipline can become beacons of privilege in this space. Endurance is measured via selfies taken astride tricked-out stationary bikes; temperance through overpriced plates of "clean food"; and renunciation through "challenges" invented by lifestyle gurus. With modesty in short supply, the crowning ethic of Instagram becomes the so-called humblebrag, a fitting portmanteau for our times.

The British writer and art critic John Berger seemed to foresee many of these trends and dynamics (indeed, his book *Ways of Seeing* was something of an inspiration for the present volume). A half-century ago, in a brilliant analysis of the magazine advertising of his day, Berger remarked,

> The image . . . makes [the consumer] envious of himself as he might be. Yet what makes this self-which-he-might-be-enviable? The envy of others. Publicity is about social relations, not objects. Its

> promise is not of pleasure, but of happiness: happi-
> ness as judged from the outside by others.

If anything, Berger's remarks are even more accu-
rate when applied to self-promotion via social media.
We idolize ourselves, not as we are—which would be
bad enough—but as we fashion ourselves for others'
consumption.

Examples abound, but a particularly relevant case
cropped up in 2020 in a controversy spurred by influ-
encer Chiara Ferragni's *Vogue* photoshoot at the Uffizi
Gallery in Florence. When the Uffizi posted an image
of Ferragni in front of Sandro Botticelli's *Birth of Venus*
(ca. 1485) on Instagram, its accompanying text mused
that Ferragni constituted "a sort of contemporary divin-
ity in the era of social media." On the same shoot, Fer-
ragni also posed in front of Botticelli's *Adoration of the
Magi* (ca. 1475). Whether intentional or not, this had
the effect of turning the picture, and its act of adoration,
inside out, as if the wise men and even the Holy Family
had come to witness *her* glory.

While the Uffizi incident caused a furor among cul-
tural commentators, for its part the gallery pointed to
an uptick in young visitors, many in pursuit of self-
ies for their own Instagram feeds, in *imitatio* Ferragni.

In another prescient remark about advertising, Berger seemed to anticipate the way art would come to be conscripted into the economy of social media. "The quoted work of art," he writes, "says two almost contradictory things at the same time: it denotes wealth and spirituality: it implies that the [experience] being proposed is both a luxury and a culture value." What remains to be seen, in the case of the museum selfie, is whether this new brand of pilgrimage—which counts its indulgences in "likes" and "shares" instead of tokens for the afterlife—not only draws people *to* works of art, but *into* them. If visitors flock to Botticelli's *Adoration* to snap a selfie, do they look at the haloed Christ Child, or is he merely a gilded appurtenance in the cult of personal experience?

Perhaps I am being too harsh towards social media. After all, there is a risk that shaming social media users for their vanity or insensitivity—especially via the internet itself—may simply replace one spectacle with an even more damaging one. In 2017, the Israeli-German writer and artist Shahak Shapira launched a web-based project called *YOLOCAUST*, merging the word *Holocaust* with the ubiquitous millennial acronym *YOLO* (You Only Live Once). The site presented selfies posted by social media users of themselves posing amid the concrete stelae of the Memorial to the Murdered Jews of

Europe in Berlin, in what Shapira deemed disrespectful ways. As one's cursor hovered above each selfie on the site, the background was replaced by an archival image of Holocaust victims, creating the impression that the tourist was intentionally desecrating the memory of the dead. Shapira cut and pasted the users' original images without permission and noted simply that should they wish to be removed they should contact him.

The *YOLOCAUST* site was quickly visited by millions of people, eventually reaching all the individuals in the photos, most of whom made contact with Shapira and removed the original photos from their social media accounts. Before Shapira shut down the site, many of the selfie takers were the subject of excoriating comments and threats online (as was Shapira himself). Among the critics of Shapira's piece, and the public shaming it initiated, was the architect of the memorial, Peter Eisenman, who commented,

> It's like a Catholic church, it's a meeting place, chil-
> dren run around, they sell trinkets. A memorial is an
> everyday occurrence, it is not sacred ground. . . . My
> idea was to allow as many people of different gen-
> erations, in their own ways, to deal or not to deal
> with being in that place. And if they want to lark

around I think that's fine. . . . But putting those bod-
ies there, in the pictures, that's a little much if you
ask me. It isn't a burial ground, there are no people
under there.

For Eisenman the selfie takers were not so much tres-
passing the aims of the memorial, as he conceived it, but
rather participating in its function as a barometer—for
better or worse—of people's changing relationship to
Holocaust memory, including ignorance or obliviousness.

As Jon Ronson explores in his book *So You've Been
Publicly Shamed*, it is hardly self-evident that an asinine
selfie—or, for that matter, a callous one—is sufficient
justification to expose individuals to the cruel spectacle
of internet infamy, an auto-da-fé that can last months
or even years. Jesus gives us good reason to be suspect of
the self-gratification of social media, but it seems equally
clear that he would have recoiled at the weaponization
of shame. His denunciation of such hypocrisy feels just
as relevant as it did twenty centuries ago:

How can you say to your neighbor, "Friend, let me
take out the speck in your eye," when you yourself
do not see the log in your own eye? You hypocrite,
first take the log out of your own eye, and then you

will see clearly to take the speck out of your neigh-
bor's eye. (Luke 6:42)

If this pithy quote sounds like perfect fodder for a meme
or hashtag, you're not wrong. Type in #LogInYourEye
to Twitter and you'll see a stream of content devoted to
denouncing hypocrites . . . and an equally long torrent
of tweets denouncing these denouncers as hypocrites!
The internet makes for a very poor courtroom, to say
the least. But it helps make painfully clear the point
of Jesus's teaching. Clarifying our own moral vision is
more than enough work for a lifetime. And when we do
it right, there's not a chance in hell we'll make it to our
neighbor's sins.

EYEWITNESS TESTIMONY

It's clear that Jesus detests hypocrisy. And keeping an eye
out for insincerity is certainly one crucial tool for navi-
gating the moral landscape. But how else can we deter-
mine we are trudging in the right direction, toward the
truth itself? What signposts and landmarks should we be
on the lookout for? Moreover, what do we see, and how
do we know when we actually get there?

The authors of the Gospels faced these concerns
head on. Well aware of the numerous oral and written

traditions about Jesus's words, actions, and identity circulating around Judea in the decades after his death, the evangelists went to great pains to prove to their readers that they could be trusted absolutely, especially when it came to the most *in*-credible revelations about Jesus. Again and again, they emphasize that the key events they describe were directly perceived, reliably transmitted, and impeccably recorded.

When relating how the details of Jesus's crucifixion align with the predictions of the Hebrew prophets, John reassures listeners and readers that "he who saw this has testified so that you also may believe. His testimony is true, and he knows that he tells the truth" (John 19:35). Luke goes even further. He begins his Gospel by anchoring it in eyewitness testimony and providing a contemporary (Theophilus) with an account of his methodology, meant to establish an accurate, unbroken chain of transmission.

> Since many have undertaken to set down an orderly
> account of the events that have been fulfilled
> among us, just as they were handed on to us by
> those who from the beginning were eyewitnesses
> and servants of the word, I too decided, after inves-
> tigating everything carefully from the very first,

> to write an orderly account for you, most excel-
> lent Theophilus, so that you may know the truth
> concerning the things about which you have been
> instructed. (Luke 1:1–4)

Luke's rationale here is interesting. On the one hand, he is careful to praise the "orderly account" handed down by his predecessors "from the beginning." Yet despite this apparently flawless narrative, he feels compelled to "investigat[e] everything carefully" and produce his own "orderly account." As if presenting a case in a court-room, Luke is at exceeding pains to retrace the steps of his investigation, illustrating how perfectly all the facts line up.

In their original context, and through the centuries, the insistence of John and Luke that they had relied on eyewitness accounts must have struck many read-ers as incontrovertible evidence of their veracity. For many readers of faith today, the same is true. Perhaps even more so. The evangelists were writing for proto-Christian communities, just beginning to coalesce around certain beliefs and practices. Their words would not become "scripture," with all the authority that entails, until later. Once regarded as gospel, however, such eyewitness accounts become doubly authoritative.

In the words of the children's hymn: this I know, for the Bible tells me so.

But what if we were not talking about the Bible, a text billions of people through the centuries have had a vested interest in taking as "gospel truth"? Is eyewitness testimony—or, in the case of the evangelists, reference to an unnamed and unverifiable eyewitness account only they have consulted—really the gold standard of evidentiary proof? We need only think of the myriad cases of witnesses who have given mistaken or deliberately false testimony under oath—hand on the Bible, no less—to raise serious doubts about eyewitness accounts.

In America, though hardly this country alone, people of color have continually and disproportionately fallen victim to false convictions based on purportedly unimpeachable testimony. Indeed, the only eyewitnessing really done in many cases has been in the courtroom itself, in which the skin color of the defendant—and often the contrasting skin color of witnesses, juries, and judges—has provided all the evidence apparently needed to determine guilt. Recently, investigators unearthed an unserved warrant for the arrest of Carolyn Bryant Donham, now in her eighties. In 1955, Donham accused the Black fourteen-year-old Emmett Till of whistling at her at a Mississippi store, setting in motion one of

the country's most infamous lynchings. The warrant names her in Till's kidnapping, leading to his torture and murder—crimes her husband and his half-brother admitted to after their acquittal by an all-white jury. Despite all we know now about these events, a grand jury refused to indict Donham in 2022.

Change has been similarly slow, sometimes nonexistent, across the country. As I write this, there are multiple stories in the national press of the exoneration of Black men convicted on flawed or outright false eyewitness testimony. Among the most egregious is the case of Kevin Strickland of Missouri, sixty-two years old, who served forty-three years for a triple homicide in 1978. In exonerating Strickland, the judge for the District Court of Appeals noted that Strickland "had been convicted despite a lack of physical evidence linking him to the crime scene, that another man convicted in the killings said Mr. Strickland had not been involved and that the only eyewitness had later tried to recant her testimony," given while wounded and under pressure from police. It is hard to imagine a more profound example of the fraught nature of eyewitness testimony, or a more damning indictment of the biases and inequities of the American criminal justice system.

This acute failure was driven home for me in 2017, when I had the privilege to work with the artist Ndume Olatushani on the *Stations of the Cross* public art project I co-curated in Washington, DC. Olatushani was convicted and sentenced to death for murder in a state he had never even visited, largely based on testimony coerced by police. After twenty years on death row, a court eventually ruled that Olatushani could be freed immediately on the condition that he forgo his right to formal exoneration (and thus restitution), which he accepted rather than potentially endure years more in prison as the legal process continued to grind along.

For the exhibition, our curatorial team asked Olatushani to respond to the theme of the first Station of the Cross, in which Jesus is condemned to death by the crowd. The artist created an installation of figures in orange prison jumpsuits—arms splayed to suggest crucifixion—on the front lawn of the United Methodist Building, at the east end of the National Mall (figure 3). A direct line of sight connected these life-size figures to the US Supreme Court, whose façade loomed across the street. The garish color of the uniforms, meant to deter prisoners' escape, instead served to capture the attention of passersby and direct them to the artist's protest

signs, decrying the "cradle to prison pipeline." In defiance of a system so quick to contrive and then believe the "evidence" of its eyes, Olatushani offered a somber act of counterwitness. How, I wondered in front of this work, do we train ourselves to see and receive *this* kind of witness—raw, troubling, but real—rather than the kind that sent Olatushani to prison?

Unlike the evangelists, interestingly, Jesus himself treats eyewitness testimony ambivalently, something we first touched on in chapter 1 in the story of the woman accused of adultery (John 8:1–11). Towards the end of John's Gospel, when Jesus appears to his disciples after his resurrection, one follower, Thomas, is absent (John 20:24). Thomas refuses to take the others' testimony at

face value, insisting he won't believe Jesus has returned
from the dead unless he is able to cast his own eyes
upon his master's pierced flesh. When Thomas finally
does behold Jesus, he exclaims, "My Lord and my God!"
(John 20:28). His teacher, however, takes the opportu-
nity to gently reprove his disciple: "Have you believed
because you have seen me? Blessed are those who have
not seen and yet have come to believe" (John 20:29).

The episode is famous—the poor disciple is forever
tarnished by the moniker "Doubting Thomas"—yet
deceptively complex. The biblical text does not actually
say that Thomas touched Jesus, and during the Ref-
ormation many Protestants argued vociferously that
Thomas believed without actually touching Jesus's flesh.
Catholics, meanwhile, stressed the importance of phys-
ical confirmation, epitomized by Caravaggio's *Incredulity
of St Thomas* (ca. 1601–2), in which the disciple slides
his finger knuckle deep into the Savior's flesh (figure 4).
The interpretive wrinkles don't end there. Consider how
different the story would be if Jesus had discouraged
Thomas's physical approach, as he did when he met
Mary outside his tomb, earlier in the same chapter (John
20:14–17). Instead, Jesus invites Thomas to confirm his
identity. Only then does he chide Thomas for needing
such firsthand experience. The dubious disciple becomes

the stand-in for any doubts readers may have. If he was convinced on the spot, we should have all the evidence we need. We don't need to see the proof of the resurrection because someone has seen before us, and—most importantly—*for* us (even if he gets in trouble for it!). The episode leaves an unresolved tension. The story ironically confirms the value of eyewitness testimony, even as Jesus suggests it is better to do without such evidence. Sometimes, it appears, seeing is indeed believing. But we see most clearly—and see Jesus most clearly, this episode suggests—when we believe first.

How satisfying or applicable is such a standard in the real world? Not very, according to some of Jesus's

contemporaries. Here's his extended exchange with a group of Pharisees regarding his identity and its verifiability:

> Again Jesus spoke to them, saying, "I am the light of the world. Whoever follows me will never walk in darkness but will have the light of life." Then the Pharisees said to him, "You are testifying on your own behalf; your testimony is not valid." Jesus answered, "Even if I testify on my own behalf, my testimony is valid because I know where I have come from and where I am going, but you do not know where I come from or where I am going. You judge by human standards; I judge no one. Yet even if I do judge, my judgment is valid; for it is not I alone who judge, but I and the Father who sent me. In your law it is written that the testimony of two witnesses is valid. I testify on my own behalf, and the Father who sent me testifies on my behalf." Then they said to him, "Where is your Father?" Jesus answered, "You know neither me nor my Father. If you knew me, you would know my Father also." (John 8:12–19)

It's easy to brush over the Pharisees' objections in this debate, especially since the sect—which laid the foundations for rabbinic Judaism—is known today primarily

through their appearances in the New Testament, which paints a less than flattering picture of them. But the Pharisees were renowned in their day for their legal acumen and rhetorical skill, and one can see why. Their point, that it's problematic to serve as one's own witness, is hardly unfair. Jesus's initial riposte—"you do not know where I come from or where I am going"—is more comeback than counterargument. In other words: mind your own beeswax!

Jesus's claim that he judges no one is ironic, to say the least. The moment these words leave his lips, he delivers a scathing judgment. It is also strange that he refers to "your law" (John 8:17). In a passage in which he trumpets his relation to the Father, it would seem more accurate for the Son of God say "his," "our," or even "my" law. Instead, he seems to distance himself from the Torah's insistence on multiple witnesses (e.g., Deuteronomy 19:15). Despite their (Christian) reputation for casuistry, the Pharisees offer a sound, even principled critique of Jesus's form of testimony. His final answer—that the Father is his witness—may satisfy readers who already know exactly who this mysterious Father really is. But it is understandably opaque to his interlocutors. Jesus is delivering the truth as he knows it, but he is operating on a different plane, from which he refuses to descend.

He surely knows that his appeal to an invisible witness—who remains notably silent here, unlike at Jesus's baptism (Matthew 3:17; Mark 1:11; Luke 3:22)—is unlikely to win the day with the skeptical Pharisees. His point is that exceptional truths can only be discerned and justified in equally exceptional ways.

The theologian Søren Kierkegaard offers a similar defense of Abraham for his willingness to slaughter his son Isaac at the Lord's behest (Genesis 22). Kierkegaard readily admits that by any normal moral standards such an action would be repugnant—it's hard to imagine anything more monstrous, in fact—but Abraham, the "knight of faith" par excellence, bows to a greater demand. He abrogates the most basic norms of human society, risking condemnation on worldly terms, to serve otherworldly ends, beyond his comprehension. And for this willingness, so the logic goes, God stays his hand and spares the lad. "The story of Abraham," Kierkegaard argues, demonstrates "a teleological suspension of the ethical. As the single individual he became higher than the universal."

It should be clear there are profound issues with this argument, however brilliantly developed by Kierkegaard. But one question looms above all others: How does one truly know one is listening to the voice of God, especially

when God seems to demand the unethical? Without the ability to certify such a demand, one risks legitimizing the actions of any fanatic misguided or perverse enough to claim they are fulfilling the will of God. Jesus's argument—that normal standards of evidence don't apply in his case—sets a similarly problematic precedent. If one was to follow his example unscrupulously, anyone could claim that they were their own witness, with God as their silent guarantor. The door to perjury would be flung wide open and a parade of false witnesses would be free to march through.

Ultimately, neither eyewitness testimony nor personal conviction—two linchpins of veracity in the Gospels—can be employed without serious qualification. Both can be helpful, even exemplary, models of testimony in the right circumstances, but they remain open to manipulation by unscrupulous or naive actors. What I want to explore further, as we conclude this section, is what happens when these two modes of witness come together. When Jesus elevates personal conviction above all else, insisting that God vouchsafes his testimony, he doesn't provide the most applicable model for ordinary people in ordinary times. But he does tell us something important about what it takes to bear witness, and specifically to be an eyewitness, in extraordinary moments to extraordinary truths.

Sometimes seeing and telling the truth requires absolute certitude in the necessity and righteousness of one's testimony. One must unflinchingly believe that God, justice, history, or even humanity itself stands on one's side, even when that belief is seemingly inexplicable. The staggering courage it takes to bear witness in extremis is especially evident in relation to the Holocaust, or Shoah (catastrophe in Hebrew). The lengths to which prisoners went to salvage memory is epitomized by the case of four photographs secretly taken at Auschwitz-Birkenau in 1944 by members of the *Sonderkommando*, Jewish prisoners forced to operate the gas chambers and crematoria. Stunningly, two photographs of gassed bodies being gathered and burnt in outdoor pits were actually taken from the opening to one of the gas chambers. Georges Didi-Huberman aptly calls this "the ultimate place of *the absence of witnesses*, analogous, if you will, in its radical invisibility, to the empty center of the Holy of Holies." The photographer, writes Didi-Huberman, "transformed the *work of servitude*, his work as a slave in hell, into a veritable *work of resistance*." As Didi-Huberman's language suggests, there is a sacred quality to such an act of testimony. It lays claim to one's humanity, even as it is denied. It wagers on a future, even as it is blotted out. We don't need to envision God in such a space to see something

divine in this action. A testimony that demands we open our eyes, and will tolerate no less.

INVISIBLE INK

In this chapter, we've looked at various ways in which we might uncover and testify to the truth. But while Jesus encourages us to find the truth and believe in it, he doesn't necessarily make doing so easy, particularly when it comes to his own identity. He is quite explicit about the dangers of following false messiahs, and repeatedly instructs his followers to be on the lookout for such charlatans.

> If anyone says to you at that time, "Look! Here is the Messiah!" or "Look! There he is!"—do not believe it. False messiahs and false prophets will appear and produce signs and omens, to lead astray, if possible, the elect. But be alert, I have already told you everything. (Mark 13:21–23; cf. Matthew 24:23–25)

Yet Jesus can be deliberately obscure and evasive when it comes to announcing his own identity, especially beyond his small circle of disciples—a motif that biblical scholars term the "messianic secret." After curing the blind man at Bethsaida, for example, Jesus quizzes the disciples:

"Who do people say that I am?" And they answered him, "John the Baptist; and others, Elijah; and still others, one of the prophets." He asked them, "But who do you say that I am?" Peter answered him, "You are the Messiah." And he sternly ordered them not to tell anyone about him. (Mark 8:27–30)

This seems like the perfect time for Jesus to enlist his disciples to help dispel rumors before they proliferate and take root across the country. And yet Jesus does the very opposite, swearing his followers to confidentiality. If this was a James Bond film, these verses would be stamped "For your eyes only."

There are many reasons Jesus might avoid disclosing his true identity. Perhaps he fears that revealing the full truth too soon might hasten his persecution and prevent him from completing his mission. Maybe he wants to test and assess the beliefs of the people he has come to redeem. Or maybe he is masking an insecurity or uncertainty about his calling. Whatever the case may be, Jesus's actions suggest that truth isn't always best served by transparency.

This preference for obscurity pervades Jesus's teachings. In fact, to draw upon a famous insight of media theorist Marshall McLuhan, sometimes the medium

of Jesus's teaching *is* the message. This comes out best, of course, in Jesus's trademark mode of instruction: the parable. Fortunately, as readers of the Gospels we are allowed to eavesdrop when he explains his pedagogical strategy to his disciples.

> The reason I speak to them in parables is that "seeing they do not perceive, and hearing they do not listen, nor do they understand." With them indeed is fulfilled the prophecy of Isaiah that says:
>
> "You will indeed listen, but never understand,
>> and you will indeed look, but never perceive.
> For this people's heart has grown dull,
>> and their ears are hard of hearing,
>>> and they have shut their eyes;
>>>> so that they might not look with their eyes,
>>> and listen with their ears,
> and understand with their heart and turn—
>> and I would heal them."
>
> But blessed are your eyes, for they see, and your ears, for they hear. Truly I tell you, many prophets and righteous people longed to see what you see, but did not see it, and to hear what you hear, but did not hear it. (Matthew 13:13–17)

It's easy to miss just how unsettling—and frankly, undemocratic—a point Jesus is making here. The fact that the majority of listeners will misunderstand the parables turns out to be a design feature, not a flaw. In this instance, Jesus *wants* to find the people wanting, and the words of Isaiah become the perfect pretext, a self-fulfilling prophecy.

The key to interpreting the parables isn't so much cognitive as it is moral. According to the passage above, sin scrambles people's sensory perceptions, rendering them unable to see what's right before their eyes. The disciples' ability to perceive the true meaning of the parables is not a credit to their special acumen—they're hardly code-breakers at Bletchley Park—but rather a mark of their faith. They see because they believe, a dynamic we've witnessed before in this chapter. And they believe, lest we forget, because Jesus leads them to believe.

Is this fair? Shouldn't the truth be equally accessible to all people, in all times and all places? Shouldn't Jesus dispense with allegories and make the truth blindingly obvious to everyone he meets? From the vantage point of the present, there's every reason to worry that Jesus's logic is exclusionary. Western intellectual culture remains heavily shaped by the Enlightenment and its abiding presumption that truth should be discoverable,

above all, by systematic intellectual exertion. Still, there are problems with the Enlightenment standard. First, Enlightenment thinkers and their successors have frequently betrayed their own logic by deeming only certain people and communities capable of "rational" thought. And second, the assumption that truths are monolithic and can be reliably mined and extracted in their elemental form is brazenly reductive. For good reason, interpreters of sacred texts in many religions have treated their scriptures more like geological formations, containing numerous, even inexhaustible layers of meaning. Following this analogy, some truths are more accessible than others, and some might be buried too deep to reach by normal means. Put another way, Jesus's assertion that most people can't handle or even recognize the truth might sound inequitable on the surface, but it safeguards the radical alterity, or otherness, of divine truth. And this is something that should keep us all humble, even the best of us.

The idea that we should approach truth—especially scriptural truth—as multilayered was quite common before the modern period. In the Christian tradition, Saint Thomas Aquinas is a prime example. Aquinas asserted that beyond its literal sense, scripture also possessed three spiritual senses (allegorical, moral, and anagogical, which

related to the future). Perhaps less familiar to Christian readers is the great medieval Jewish philosopher Moses Maimonides, who was in fact an important influence on Aquinas. In his *Guide for the Perplexed*, a work composed for a single, gifted pupil—though it subsequently became one of Judaism's most widely respected tomes—Maimonides gives a compelling defense of inscrutability as a moral and intellectual value.

As someone who celebrated the complexity of parables, Maimonides's reflections are especially appropriate as we consider Jesus's discussion of hidden truths. Maimonides begins his *Guide* by telling his protégé,

> It is not the purpose of this treatise to make its totality understandable to the vulgar or to beginners in speculation. . . . Its purpose is to give indications to a religious man for whom the validity of our Law has become established in his soul and has become actual in his belief—such a man being perfect in his religion and character, and having studied the sciences of the philosophers and come to know what they signify.

Far more than Jesus, Maimonides is comfortable being unabashedly elitist when describing his intended

audience. If Jesus sets a high bar for interpretation, Maimonides turns it into a pole-vaulting competition. Ultimately, Maimonides makes clear, we are all are doomed to miss the cut, including Maimonides himself and his esteemed reader.

> You should not think that these great secrets are fully and completely known to anyone among us. They are not. But sometimes truth flashes out to us so that we think that it is day, and then matter and habit in their various forms conceal it so that we find ourselves again in an obscure night, almost as we were at first.

Our great hope when we are inevitably plunged back into darkness after a burst of spiritual insight, lies in this "almost." We hope, through divine favor, to savor the afterimage of the truth, even as it recedes from sight. To pine for more borders on heresy, for it presumes that what God has carefully shrouded in scripture—especially about Godself—should be revealed, merely because we wish it so.

Even if we are inclined to agree with this point—that some truths are better kept under lock and key, with restricted access—it must be noted that this comes with

its own risks. When the sacred is something obscure or unknowable, to be discerned only by a select few with their own arcane methods, it can become tricky to tell when heterodoxy—let alone heresy or occultism—begins to take root. The potential problems with such hermetic practices of truth seeking are not only theological. They can quickly become political, as often witnessed in conspiracy theories, from the antisemitic Protocols of the Elders of Zion, first spread more than a century ago, to the rapid (and sometimes overlapping) growth of QAnon in recent years.

QAnon originally centered around an alleged government insider, "Q," who began anonymously spilling "top-secret" information on shady online forums. Soon, QAnon developed an entire eschatology, loosely centered on the belief in a "Great Awakening," when a blood-sucking cabal of global elites would be unmasked. During the pandemic, QAnon gained wider traction as many people on lockdown seemed to deal with isolation, frustration, and uncertainty by going deeper and deeper down online rabbit holes. Animated by a suspicion of the government and a distrust of experts—especially medical authorities—QAnon started to attract believers not only from the far right but also the far left. In 2021, polling revealed a terrifying fact: 14 percent of Americans,

roughly equivalent to the percentage of mainline Protestants in the country, could be classed as full-on QAnon believers. While one might hope the church would have an inoculative effect, in some contexts—especially among white evangelical congregations—it has actually provided a breeding ground for new and deadly variants of QAnon.

How do we separate this kind of dangerous, unhinged truth seeking from the proper pursuit of religious truth? If we look closely at the Gospels, including the opening passage in this section, Jesus offers us some powerful tools. Above all, Jesus demands profound humility, even from those with whom he shares the world-altering truth of his identity. He reminds the disciples just how fortunate they are to have received this revelation, which "many prophets and righteous people longed to see" (Matthew 13:17). In Luke's rendition of this episode, Jesus praises God for having "hidden these things from the wise and the intelligent and hav[ing] revealed them to infants" (Luke 10:21). It's not because of their special merit or cleverness that Jesus discloses the truth to his disciples, but rather their faith in him, and—just as importantly—his faith in them. He tells them the truth because he loves them and wants them to know him more deeply and perfectly.

This could hardly be more different from the ethos of QAnon and other conspiracy theories. Rather than the radical humility Jesus encourages in his flock, QAnon preaches superiority over the mindless "sheeple" who follow mainstream media sources. Instead of the patient study of cryptic matters urged by sages from Aquinas to Maimonides, QAnon promises the interpretive keys to the kingdom to anyone able to open a Facebook account. The reflexive rejection of everything that doesn't suit one's worldview as "fake news" is antithetical to the proper business of theological hermeneutics, or interpretation. Jesus doesn't ask us to reject what we see before us as a lie, but rather to seek ever-deeper truths, beyond what we see on the surface. Jesus's parables invite us to read between the lines, but the lines still matter. They're not fake.

VANTAGE POINTS

In this chapter, we've used the Gospels to help frame some of the central issues at stake when we try to discern the truth in our disorienting world. Along the way, we've identified more problems than solutions. As readers will suspect, that is in many ways the point. While Jesus's words and actions do suggest helpful tactics for differentiating truth and falsity, his abiding insight is just how bloody difficult this is, and how much work it takes to

do it well. In each of the three domains we examined—appearance, testimony, and interpretation—we identified the dangers posed by false representations, from idolatry to fanaticism to delusion. Against such moral perils, Jesus prescribes an ethical vigilance that is at once inspiring and daunting. He reminds us that we must be willing to cast a critical eye upon ourselves and unmask our own conceits, prejudices, and fabrications, however embedded, socially acceptable, even invisible they may have become.

Our inability or unwillingness to practice such scrutiny and accountability has been scathingly evoked by prophets both ancient and modern. But few have done it as incisively as Monty Python (a rather underrated theological authority). In the film *The Life of Brian*, the Pythons' classic send-up of the Gospels, a misunderstood everyman (Brian) gets continually mistaken for the messiah by the people of Jerusalem, who cling to his every word. In one scene, Brian tries desperately to fob them off. Here's the classic exchange:

> BRIAN: Look, you've got it all wrong! You don't need to follow me. You don't need to follow anybody! You've got to think for yourselves! You're all individuals!
>
> CROWD: Yes! We're all individuals!

BRIAN: You're all different!
CROWD: Yes, we are all different!
MAN IN CROWD: I'm not . . .
CROWD: Shhh!

Ironies abound. The masses are so eager to be led, they can't actually follow what Brian is saying . . . about following. And, best of all—especially for a movie that was widely boycotted for being anti-Christian—Brian's attempt to disperse his followers leads him to deliver an ethical lesson not far from that of Jesus himself: "You've got to think for yourselves!" With a little tweak, this serves us well as the motto for this chapter: You've got to *look* for yourselves. Whether online, in a courtroom, or among a crowd, discernment depends on our capacity to stand apart, an act that can yield both uncommon perspective and acute vulnerability.

RECOGNIZING OTHERS

A couple years ago, a story went viral about two kindergartners, one Black and one white, who wanted to play a cute prank on their teacher. The white boy asked his parents to have the hairdresser shave his head, so he'd look just like his Black best friend. When they got to school, they tried swapping places, figuring there was no way their teacher would be able to recognize who was who. To their delight, the teacher played along with the boys' caper.

As it racked up tens of thousands of shares, the story quickly became a media sensation, with commentators repeatedly celebrating the innocence of the boys, for whom race was seemingly invisible, or at least no more defining than a quick trim. In an American society permeated by racial prejudice, the story seemed to offer viewers a redemptive glimpse of an Edenic world, beneath or before race.

The children were indeed adorable, and their friendship genuinely endearing. But the packaging of

the episode by the media missed an opportunity to tell a much more nuanced story of attitudes and assumptions about race in America. For one, the boys' story was mainly framed by white newscasters with white audiences in mind, as a heartwarming tidbit to savor over morning coffee. There was little concern that it might be bittersweet, even painful, for viewers of color to imagine the many ways in which race and racism might come to impact the lives of these kids.

Second, newscasters' chuckles over the buddies' naivete, however good-natured, celebrated the children for what they ostensibly missed rather than what they actually *saw*. The kindergartners weren't just unaware of "the real world," in which perceptions and prejudices about race are so often, and so devastatingly, definitional. The kids were living in their own, no less real, reality. And—just as importantly—the beauty of their vision made others want to share in it. Their little ruse inspired adults who would otherwise "know better"—parents, hairdressers, teachers, and reporters—to act as if they didn't in order to preserve the kids' "illusion."

The lesson here of course isn't that as adults we can or should pretend systemic and structural racism doesn't exist, or that we should prevent kids from learning about racism's roots and impact. But the vignette does illustrate

that racism should not be treated deterministically, as an inevitable or immutable fact of life. While racism is an acute and real force in society, race itself is a dubious ideological construct, presented as objective and obvious, yet flimsy enough for schoolkids to see right through. As Barbara J. Fields and Karen E. Fields persuasively argue in *Racecraft*, race in America "came into existence at a discernible historical moment for rationally understandable historical reasons and is subject to change for similar reasons." It might be newsworthy in contemporary America, but the idea of two kids with different skin tones swapping places would be unremarkable in myriad other cultural and historical contexts. Anthropology is rife with examples of cultures for which skin color has been incidental, and characteristics like hairstyle considered far more revealing markers of identity. In fact, the Bible itself devotes significant attention to hairstyle as a distinguishing symbol of social and sacred status (e.g., Numbers 6:5), something our two kindergartners could easily get behind.

Ultimately, the story of these two similarly coiffed kids reveals the fundamental distinction between sight and recognition, the subject of this chapter. Recognizing others isn't merely a matter of identifying visual characteristics. It is an overdetermined act by which we map our

imbricated memories, beliefs, assumptions—and, sadly, prejudices—onto the faces of those before us. We recognize what we want to see, or believe we already have seen, even if it doesn't do others—or ourselves—justice. The astonishment that two kids could recognize themselves in one another, without seeing race first and foremost, lays excruciatingly bare the implicit and explicit biases that shape American culture.

It's clear we need to repair and retrain our sense of recognition, especially—though certainly not exclusively—when it comes to issues of racial difference in America. It's also clear that to do so we need a language that inspires rigorous self-reflection while remaining comprehensible within existing moral frameworks. For some, this discourse will come from critical theory, which has indeed been prescient in the diagnosis and analysis of these issues. Yet the terminology and methodology of critical theory struggle to resonate with many people. And it's here that theological language, especially anchored in the insights of Jesus, can offer key resources for refashioning how we perceive and talk about difference. As we proceed in this chapter we'll look to crucial observations by Black theologians such as Howard Thurman and James Cone, who keenly understood how Jesus recognized, and can be recognized by, the disenfranchised.

Above all, Jesus provides a model of recognition based not on what we want or expect others to be, but who they really are. It isn't so much that he sees *through* people but *into* them. He doesn't ignore differences—as we've seen, he actively seeks out people in marginal positions—but neither does he treat these characteristics as ontological, as states of being. Christologically, one might say he recognizes the essence of people because, as their Creator, he has *already* seen them. But there is another possibility, open to Christian believers but also to those who don't hold a conviction in Jesus as Christ. It is that Jesus looks at others with a love that does not objectify or transfix the Other but instead allows them to *become* themselves in his presence. Where most of us bring to relationships what we think we know of a person, Jesus seems uniquely capable of recognition without preconception. While this example might be impossible to emulate perfectly, it provides a powerful point of orientation, a lodestar.

TRUE COLORS

Perhaps no one has delved more deeply into the experience of relatedness than Martin Buber, the great twentieth-century Jewish philosopher. Buber explored this theme throughout his long career but he set out the principal dynamics in his opus *Ich und Du* (I and You)

from 1923. Buber's central argument there is that most of our relationships involve our objectifying another person—treating that other person as an "it." But true relationships, real relationships, those our best selves yearn for, involve engaging the other in a spirit of genuine reciprocity. When we do that, Buber says, we treat the other not as an objectified "it," but as a "you." And it is through this I-You dialogue that we open ourselves to the Divine, the Other beyond all others.

In a highly allusive, poetic style, inflected by his training in art history, Buber paints a vivid picture of what this I-You relationship looks like. Interestingly, while the text is steeped in Jewish texts and traditions, he finds a recurring model in Jesus. According to Buber, Jesus is preeminently gifted at remaining in I-You relationship, whether his addressee is an individual in dire straits or the Father he addresses in heaven. Jesus does, like other people, have his favorites, and Buber distinguishes between the feeling Jesus has for a stranger in need, for example, and a disciple he adores. Yet Buber persuasively claims that in each relationship the love of the I for the You is the same for Jesus. Buber explains,

> Feelings one "has"; love occurs. Feelings dwell in man, but man dwells in his love. This is no metaphor

but actuality: love does not cling to an I, as if the You were merely its "content" or object; it is between I and You.

When Jesus recognizes a You before him, they remain uniquely themselves, but the love that connects this I and You is deeply familiar, indeed universal.

This dynamic is especially evident in accounts of how Jesus sets about calling his twelve disciples. Given the importance that these disciples will have in his life, let alone how they will help shape a new faith after his death, one might expect Jesus to take his time choosing the right individuals. Perhaps draw up a long list, conduct a few interviews, even check a few references. And yet he seems to do the exact opposite. He selects his disciples almost instantaneously, the moment he lays eye on them. It is love at first sight for both Jesus and his acolytes. For their part, the disciples seem to feel truly seen, *recognized*, by this strange man they have never met before. To use Buber's terminology, Jesus calls each person to him as a You, and the power of this address is so direct there can be no question of evasion or demurral. The only answer is yes.

These calling narratives are at once momentous—changing the destiny of the disciples in an instant—and strangely casual. It's almost like Jesus is assembling a

team for pickup basketball in the park. Take this passage in Matthew, in which Jesus collects not one but four disciples, a full third of his coterie, on a single stroll.

> As he walked by the Sea of Galilee, he saw two brothers, Simon, who is called Peter, and Andrew his brother, casting a net into the sea—for they were fishermen. And he said to them, "Follow me, and I will make you fish for people." Immediately they left their nets and followed him. As he went from there, he saw two other brothers, James son of Zebedee and his brother John, in the boat with their father Zebedee, mending their nets, and he called them. Immediately they left the boat and their father, and followed him. (Matthew 4:18–22)

Jesus's metaphor about fishing for people is a powerful piece of foreshadowing for readers, yet one can only assume a bit befuddling for the fishermen in question. And yet such is the power of Jesus's gaze and command that they still drop everything and obey. Even when a disciple does think to ask a follow-up question, Jesus relies on the power of recognition, rather than any logical justification, to make his case.

> When Jesus saw Nathanael coming toward him,
> he said of him, "Here is truly an Israelite in whom
> there is no deceit!" Nathanael asked him, "Where
> did you get to know me?" Jesus answered, "I saw
> you under the fig tree before Philip called you."
> Nathanael replied, "Rabbi, you are the Son of God!
> You are the King of Israel!" Jesus answered, "Do you
> believe because I told you that I saw you under the
> fig tree? You will see greater things than these."
> (John 1:47–50)

The fact that Jesus is able to spot Nathanael from a distance would normally be evidence of decent eyesight, nothing more. But for Nathanael the point seems to be that Jesus knew him, him specifically, the moment he laid eyes on him. He is satisfied not by Jesus's mastery of any specific piece of knowledge about him, but by the depth of his recognition.

This kind of recognition does not necessarily need to be positive to be affirming. While it is no doubt gratifying to be singled out for one's trustworthiness, like Nathanael, it is no less affecting—and perhaps even more so—to feel seen and loved in one's failings, as Matthew finds.

> As Jesus was walking along, he saw a man called Matthew sitting at the tax booth; and he said to him, "Follow me." And he got up and followed him. And as he sat at dinner in the house, many tax collectors and sinners came and were sitting with him and his disciples. When the Pharisees saw this, they said to his disciples, "Why does your teacher eat with tax collectors and sinners?" But when he heard this, he said, "Those who are well have no need of a physician, but those who are sick. Go and learn what this means, 'I desire mercy, not sacrifice.' For I have come to call not the righteous but sinners." [Matthew 9:9–13]

Caravaggio captures the transfixing power of Jesus's gaze in his iconic painting of this scene (ca. 1599–1600, figure 5). The tax collector is counting coins in a dark, dusty room when a lanky Jesus enters. Light streams in from a window just above Jesus's head, bisecting his delicate halo, and alights on Matthew's astonished face as their eyes meet. Matthew holds his hand to his chest, as if to say, "Me? Really?" While Jesus's outstretched arm points to Matthew, his index finger doesn't so much point as hang suspended in the air, like Michelangelo's Adam reaching toward God in the Sistine Chapel. On the one

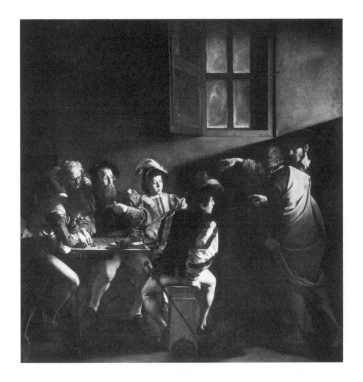

hand, this gesture may suggest Jesus's theological sta-
tus as a new Adam. But it also invites us to reflect on
what—or who—else is being created in this instant. We
are witnessing the moral awakening of Matthew, who is
recognizing his own better self through Jesus's eyes.

It seems a tall order to emulate a look of such trans-
formative power. But the capacity to recognize others as
they are, to help them recognize *themselves*, does not need
to constitute a spiritual summons from on high. It can

begin with something as seemingly prosaic as addressing someone by their name or pronoun; in Buberian terms, language that truly recognizes that individual as "You." Today, this basic sign of respect is under threat. In an important case in Kansas, for example, attorneys for a middle school math teacher filed a complaint in federal court alleging that *her* First Amendment rights were infringed by school policy directing her to use a transgender student's preferred name and masculine pronoun. The complaint reads,

> Ms. Ricard [the teacher] believes that God created human beings as either male or female, that this sex is fixed in each person from the moment of conception, and that it cannot be changed, regardless of an individual person's feelings, desires, or preferences. . . . Any policy that requires Ms. Ricard to refer to a student by a gendered, nonbinary, or plural pronoun (e.g., he/him, she/her, they/them, zhe/zher, etc.) or salutation (Mr., Miss, Ms.) or other gendered language that is different from the student's biological sex actively violates Ms. Ricard's religious beliefs.

The logic here is not only scientifically dubious—it appears oblivious to intersex identity, for example—but

scripturally dubious, despite its pretensions to biblical literalism. For starters, neither of the *two* stories of the Creation of humans in Genesis actually involves conception, and both are in fact ambiguous about how sex is determined. Moreover, Ms. Ricard's beliefs about how "sex is fixed" during conception represent an anachronistic mix of modern biology (presumably chromosomes) with ancient beliefs. Above all, the complaint displays a stunning hypocrisy, brushing aside a student's "feelings, desires, or preferences" regarding their *own* gender expression, while asserting the teacher's absolute autonomy to address them as *she* wishes, based on what *she* speculates about their biology. The most cherished "religious" freedom is, by this twisted logic, the right to *dis*-regard the other. To *not* recognize them.

In the end, the people most willing to say "You" as Jesus did, to recognize people on their own terms, may never mention religion at all. We began this chapter by talking about haircuts, and it feels fitting to return to the subject here. There's something intimate and ritualistic about visiting the right hairdresser. And there's a reason salons and barbershops often become places for informal therapy and community bonding as much as anything cosmetic. I've felt the lack of these visits keenly in the dozen years since my sister Whit, a talented hairdresser, passed

away. She was the last professional to cut my hair—I've been doing it (poorly) ever since—and she had a natural way of coaxing out a steady stream of confessions and revelations without one realizing it. There was something reassuring about her gentle patter and cascading giggles as she clipped away, and it hardly surprised me that her clients were as devoted to her as to a parish priest. Whit was able to sense intuitively the fraught, complicated ways in which people's sense of self-worth was braided together with feelings about their appearance. And she took special pride in surprising people—especially those grown accustomed to feelings of shame or inadequacy—with their own beauty, reflected back at them.

I thought of Whit instantly when a transgender friend of mine, Michael, revealed how destabilizing, even traumatic, it had been for him to visit hair salons as a younger person, especially a teenager. In those years, then identified as a girl, all the myriad pressures of gender conformity seemed to be focused through these visits like a prism. Nowhere was it more apparent what one *should* feel about one's body and how one *should* represent oneself to others. In his twenties, as Michael transitioned, he sought out a hairdresser who specialized in working with trans clients and understood how triggering haircuts could be for them. This was a place without

any awkward stares from other clients as they waited, without snickers among staff, and without explanations of any sort required. Before hearing Michael's story, I must admit that I had never really countenanced how excruciating visits to the hairdresser might be for nonbinary and transgender people, nor had I understood how healing and affirmative the right environment could be. I don't know if my sister ever had a trans or nonbinary client in her too-short life and career, but I have no doubt she would've understood immediately how she could be of service, not just as a professional but a person. One uniquely capable of recognizing the You in front of her.

SHOWING MERCY

The year after my sister died, I started to develop a strange habit. I was living in Manhattan at the time, and for the most part I was in a fog. I took to walking up and down the Upper West Side for hours every evening and stopping at supermarkets at 2 or 3 a.m., meandering aimlessly under the fluorescent lights, rarely buying anything. I remember being baffled at how busy the world could be in those hours, and how utterly unconcerned with my own private universe of grief—a fact that was reassuring and insulting in equal measure. It didn't matter that I couldn't sleep, then somehow couldn't wake up.

Overpriced cereal boxes and squishy produce still had to be stocked with the same urgency, every night.

But while the world seemed oblivious to my pain, I felt more alert to others' suffering than I had ever been. It was as if I had suddenly developed the capacity to see infrared light waves or hear ultrasonic frequencies. That was part of the reason I took to walking so much in the first place. Taking the subway in New York was unbearable. Sitting on the train, with everyone muted, isolated in their own thoughts—smartphones weren't ubiquitous yet—I would grow hyperattentive to every emotion that seemed to flicker across passengers' faces. I have no idea now whether what I saw then was accurate. But if a slight grimace crossed their lips I was certain it was a painful memory that had just surfaced. A trace of red around the eyes, the faintest sniffle, indicated a fresh trauma, liable to spill out in tears. As the months went on, my powers, if I can call them that, started to wane. Where I had been a seismograph before, my needle dancing across unfurling pages, I gradually registered less and less in the faces of those around me. The world seemed to be in less pain. Which of course signaled very little about the world, but a lot about me. I had started to return to life.

My sense that private pain had opened new realms of perceptions, new conduits to others, is certainly not

unique. Pain transforms and reorients, often without our consent. One could pick numerous examples, but I think in particular of the final years of Oscar Wilde. A prodigious *bon vivant* for most of his life, Wilde was sentenced to two years' hard labor in prison for "gross indecency"—a cruel antihomosexual statute—for his consensual relationship with Lord Alfred "Bosie" Douglas. As he languished in jail, Wilde composed a long and winding letter to his estranged lover, in which he attempted to make sense of his stunning fall from grace and find purpose in his humiliation and sorrow. The letter was published posthumously as *De Profundis*, meaning "out of the depths," the opening words in Latin from Psalm 130 (129 in the Vulgate).

Hardly known for his Christian piety before imprisonment, Wilde found himself ineluctably drawn to the Gospels—some of the only literature he was allowed in his cell—and he began to see himself in the life of Jesus. In Jesus's suffering, and in Jesus's attention to the suffering of others, Wilde found a compelling image that illuminated his own condition. "In a manner not yet understood of the world," writes Wilde, Jesus "regarded sin and suffering as being in themselves beautiful holy things and modes of perfection." While Wilde never fully explicates this fascinating insight—perhaps because he

was only allowed to write a single page at a time, each of which was confiscated upon completion—he alludes several times to the idea that pain paints its own unique portrait. "Behind sorrow there is always sorrow," he writes at one point. "Pain, unlike pleasure, wears no mask." Where Wilde had been an unabashed maestro and champion of artifice in his plays and stories, he comes to find a higher moral and aesthetic value in the sheer, layer-less simplicity of pain. For Wilde, Jesus's greatest accomplishment—Wilde refers to Christ's life as "a work of art"—was to make suffering perfectly lucid, and thus perfectly universal. In other words: pain recognizes pain.

But what happens when pain subsides? Does the memory of suffering prove a sufficient basis for lasting solidarity? Sadly, even the most extreme pain has often shown this not to be the case. We might wish that survivors of trauma, from the intensely personal to the world historical, would exit these experiences with an abiding commitment to empathy and mercy. But this is both unrealistic and unfair. To hold the victim of discrimination, abuse, or persecution to a higher ethical standard because "they should know better" imposes a perverse double standard. It risks attributing a morally corrective force to the very violence these victims experienced in the first place, as if their oppression had a higher purpose

or value all along, and the survivor did something wrong by failing to identify its lesson. From his terrible vantage point upon the cross, Jesus was able to look upon his torturers with benevolence and pray, "Father, forgive them; for they do not know what they are doing" (Luke 23:34). But this sets a lofty—one might well say, divine—standard of mercy. And it would be dangerous to rely on the unique but terrible insights of affliction to foster lasting fellowship.

How else, then, might we generate a truly horizontal gaze? How do we ensure we truly see the suffering of the Other, in a spirit of recognition rather than pity? The theologian Howard Thurman, a major influence on Martin Luther King Jr. and other civil rights leaders, acutely perceived the danger of a morality based merely on pity. In *Jesus and the Disinherited*, first published in 1949, Thurman writes,

> It is exceedingly difficult to hold oneself free from a certain contempt for those whose predicament makes moral appeal for defense and succor. It is the sin of pride and arrogance that has tended to vitiate the missionary impulse and to make of it an instrument of self-righteousness on the one hand and racial superiority on the other.

As Thurman contends, such vertical charity has very little to do with the kind of mercy preached and practiced by Jesus. And it may well do terrible harm, feeding the fires of colonialism and racism in the name of "the White Man's Burden," or similar conceits. Much better, but still limited, is the extension of love only to those whom one already sees as kin. Thurman addresses the shortcomings of this perspective with a reflection on his own experience, growing up in segregated Florida.

> I grew up with this interpretation. I dare to say that, in the white churches in my little town, the youths were trained in the same narrow interpretation applied to white persons. Love those who have a natural claim upon you. To those who have no such claim, there is no responsibility.

As Thurman unflinchingly observes, Jesus calls for a love without perimeters, one that trespasses perceived boundaries of group identity, whether intuited, inherited, or enforced. It is not enough to love only the people who share one's experiences and commitments, one must strive to recognize those to whom one feels no "natural" affinity. And while this vision demands justice for the disinherited, it seeks recognition in both

directions, "a common sharing of a sense of mutual worth and value."

Jesus provides myriad examples of this kind of boundless love throughout his ministry, in both words and action. Some of the most memorable instances involve Samaritans, who were a focal point for Jewish anxieties around religious and ethnic difference in Jesus's world of first-century Palestine. The Samaritans trace their lineage to the tribes of Northern Israel, observe the Sabbath and a number of other core practices in common with Jews, and share a common belief in the sanctity of the Torah (though their version is different and they reject post-Pentateuchal Jewish texts). Despite important commonalities, they diverged in key ways from Jews, and indeed still constitute a distinct religio-ethnic group in contemporary Israel and Palestine, where they live mainly in two small villages. As is so often the case in matters of social difference, this familiarity—close but not close enough—bred distrust and contempt between Jews and Samaritans in Jesus's time.

Set against this backdrop, Jesus looks upon the Samaritans with a remarkable degree of acceptance that often stuns those around him. At one point, residents of a Samaritan village refuse to receive Jesus, seemingly based on religious difference. Jesus is headed to Jerusalem

(Luke 9:53), home to the Temple Mount, while Samaritans hold Mount Gerizim to be sacred. The disciples are infuriated on their master's behalf, asking, "Lord, do you want us to command fire to come down from heaven and consume them?" but Jesus "turned and rebuked them" (Luke 9:54–55). Later, Jesus heals a group of ten men from a skin disease. Yet the only one who turns back to look at Jesus and thank him is a Samaritan, leading Jesus to ask, "'Were not ten made clean? But the other nine, where are they? Was none of them found to return and give praise to God except this foreigner?' Then he said to him, 'Get up and go on your way; your faith has made you well'" (Luke 17:17–19). Jesus does not just celebrate the man's good manners, he goes out of his way to validate the authenticity of his "faith," directed to the same God, whatever differences abide between Jews and Samaritans.

Most famously of all, Jesus tells what comes to be known as the parable of the Good Samaritan. The story constitutes his response to a deceptively simple question from a lawyer: when we're commanded to treat our neighbor as ourselves, who counts as our neighbor (Luke 10:29)? In Jesus's parable, two Jews of high religious rank, a Kohen (priest) and a Levite, cross the road to

avoid making eye contact with a victim of robbery, desperately in need of help. In sharp contrast, "a Samaritan while traveling came near him; and when he saw him, he was moved with pity" (Luke 10:33). Where others go out of their way *not* to see the man in need, the Samaritan takes the all-important first step. By approaching the man, he puts himself in position to be ethically implicated, to become responsible for his fellow traveler. Then he goes the extra mile, providing urgent care and paying for the victim to recover in an inn (Luke 10:34–35). The episode ends—fittingly for a parable about recognizing others' needs and one's own responsibilities—with a final recognition. Jesus invites his interlocutor to determine for himself who the true neighbor is in the parable. The lawyer concludes correctly, "The one who showed him mercy," and Jesus responds, "Go and do likewise" (Luke 10:37). Or, he might well have said, *look* and do likewise.

Given the clarity of Jesus's moral vision in sequences like the one above, it can be shocking when Jesus fails to follow his own insights. And yet there is perhaps an even greater moral power in watching Jesus recognize his shortcomings. Nowhere is this more compelling than in the following episode, which Wilde calls one of his favorite biblical passages:

[Jesus] entered a house and did not want anyone to know he was there. Yet he could not escape notice, but a woman whose little daughter had an unclean spirit immediately heard about him, and she came and bowed down at his feet. Now the woman was a Gentile, of Syrophoenician origin. She begged him to cast the demon out of her daughter. He said to her, "Let the children be fed first, for it is not fair to take the children's food and throw it to the dogs." But she answered him, "Sir, even the dogs under the table eat the children's crumbs." Then he said to her, "For saying that, you may go—the demon has left your daughter." So she went home, found the child lying on the bed, and the demon gone. (Mark 7:24–30)

The moral force of the woman's retort instantly turns the tables on Jesus. From her inferior position, "bowed down at his feet," she nonetheless commands his gaze. In her eyes, Jesus perceives the true power of his own teaching, recognizing a more expansive conception of his calling. For Wilde, this exchange is evidence of an underrecognized aspect of Jesus's ministry. Jesus "had the power of not merely saying beautiful things himself, but of making other people say beautiful things to him."

What Wilde finds so beautiful is the paradox behind the woman's words. The lowliness she embraces is precisely what makes her worthy of Jesus's merciful love. In the end, Wilde suggests, love is always a gift that surpasses merit. "Love is a sacrament that should be taken kneeling," he writes poignantly, "and *Domine, non sum dignus* [Lord, I am not worthy] should be on the lips and in the hearts of those who receive it."

What Wilde does not explain sufficiently is how Jesus could be so dismissive in the first place. Here, Thurman provides a helpful approach, contextualizing Jesus's disdain, without excusing it.

> [Jesus's response] had in it all the deep frustration which he had experienced, and there flashed through it generations of religious exclusiveness to which he was heir. "What right has this woman of another race to make a claim upon me? What mockery is there here? Am I not humiliated enough in being misunderstood by my own kind? And here this woman dares to demand that which, in the very nature of the case, she cannot claim as her due."

Ever true to his concern for what the Gospels might say to those "with their backs against the wall," Thurman

identifies how anxieties about belonging drive Jesus's reaction. He refers to Jewish ideas of election, certainly a central element in the worldview of Jesus and his contemporaries, while introducing a modern discourse of "race," connecting Jesus to African American experience. In doing so, Thurman helps us visualize the complexities of identity boundaries, which might sustain communities in crucial ways, yet also limit and undermine them in others. The fact that even Jesus struggles to see such boundaries from another perspective—initially failing to apply his own first principle of love—might seem discouraging at first. But it is an instructive reminder that love does not occur in a vacuum, between abstract entities. It is seen, felt, and practiced amid the frictions and entanglements of life.

IN PLAIN SIGHT

I began the previous section by talking about how my sister's death changed my way of seeing, especially the way I recognized pain in others. But there's an even more obvious way in which her passing changed my patterns of recognition. In the early weeks and months of grief, I was often convinced I had caught a glimpse of Whit, especially in airports. Maybe it was because everyone was in motion there, brushing past in a blur, partially

visible. It wasn't hard in those moments to think I'd seen a wisp of her shiny, mahogany-colored hair, for instance, as someone receded from view down an escalator, or through a checkpoint. Perhaps the unreachable, unverifiable nature of such recognitions wasn't just coincidental but exactly what I was looking for. Sometimes—before I snapped back into the present—I'd find myself indulging in the illusion that it really had been her, as if she'd joined witness protection, or faked her own death. She must have had her reasons, I figured in those fleeting moments. All the pain must have been necessary. She'd explain it all.

I can't help but think of these experiences when I read about Jesus's encounters with his followers after his resurrection. While I saw my sister everywhere, Jesus's beloved compatriots seem to see him nowhere in the midst of their own grief. This despite the fact that Jesus himself repeatedly told the disciples—three times according to Matthew (16:21; 17:23; 20:19)—that he would be raised from the dead after three days. Even if they found these prophecies confounding at the time, surely their master's words would have reverberated in the days after his crucifixion. Yet Jesus's closest companions can't even recognize his resurrected form when he's right in front of them. What could possibly

be going on here? What lessons should we take from the repeated scenes of misrecognition that characterize Jesus's encounters after his resurrection?

The first case of misrecognition seems to be the most explicable. In the Gospel of John, the first person to see the risen Christ is his follower Mary. She is weeping near his tomb when she encounters two angels.

> They said to her, "Woman, why are you weeping?" She said to them, "They have taken away my Lord, and I do not know where they have laid him." When she had said this, she turned around and saw Jesus standing there, but she did not know that it was Jesus. Jesus said to her, "Woman, why are you weeping? Whom are you looking for?" Supposing him to be the gardener, she said to him, "Sir, if you have carried him away, tell me where you have laid him, and I will take him away." Jesus said to her, "Mary!" She turned and said to him in Hebrew, "Rabbouni!" (which means Teacher). Jesus said to her, "Do not hold on to me, because I have not yet ascended to the Father. But go to my brothers and say to them, 'I am ascending to my Father and your Father, to my God and your God.'" Mary Magdalene went and announced to the disciples, "I have seen the Lord";

and she told them that he had said these things to
her. (John 20:13–18)

In this distraught, tear-stained state, one can imagine how
Mary might mistake her beloved, at least for a moment.
And Jesus himself seems to encourage Mary's confusion
by asking whom she seeks. This could be feigned naivete
on his part, but there are other possibilities in this enig-
matic episode. Perhaps Jesus is unaware that resurrection
has changed his appearance, and if so, he might be gen-
uinely confused that Mary doesn't recognize him. Or it
might be that rejoining the living has scrambled his own
senses, meaning that it is only through hearing her speak
that he recognizes his beloved.

The detail about the gardener adds another curious
wrinkle, which has inspired a host of artistic interpre-
tations. The most famous example is Titian's *Noli me
Tangere* (ca. 1514), in which Jesus wears a translucent
loincloth and skimpy white cape (neither a cunning dis-
guise nor optimal gardening attire). In Titian's painting,
Jesus arcs away from Mary's outstretched hand like a
parenthesis (figure 6). Other works, including medie-
val manuscripts, sometimes show them making contact.
Rather than a betrayal of the text, such renderings may
echo extant variants of the Gospel, in which Mary does

touch Jesus, foreshadowing Thomas's encounter with Jesus (John 20:24–29; see chapter 3).

Ultimately, while we can say very little definitively about Jesus and Mary's encounter in the garden—which is in part the point—we can identify several key effects of this delayed recognition. Narratively, it heightens the drama of

the final "reveal," to use the parlance of reality television, focusing our attention on the context of the encounter. It also casts doubt on the reliability of sensory perceptions, especially sight alone, suggesting the need for a more spiritual faculty. Finally, this deferred recognition invites us to reflect on what it is that's truly *sui generis* about a person—what really makes them *them*—an immensely complex question when it comes to the resurrected Christ. At the most fundamental level, it raises the question of how prepared we truly are to recognize the person standing before us when they reveal their unvarnished selves, whether as they always were, or have now become.

On the road to Emmaus, recognition is held in abeyance even longer. Jesus walks for miles with two of his disciples, pretending to be a guileless traveler who has not yet heard the news about a certain Jesus of Nazareth (Luke 24:15–24). The chatty disciples are all too happy to regale him with the latest news and rumors, including reports of Jesus's empty tomb. The scene seems perfectly designed for the stage, and it's easy to imagine the audience chuckling as they watch the disciples bumble along, unaware that they're in their master's company. Jesus, for his part, remains patiently undercover. As the trio amble ahead, he uses the time to carefully explicate scriptural prophecies about the messiah—himself!

(Luke 24:25–27)—in effect readying the disciples to receive the shock of his presence.

Finally, "When he was at the table with them, he took bread, blessed and broke it, and gave it to them. Then their eyes were opened, and they recognized him; and he vanished from their sight" (Luke 24:30–31). Where Mary first recognized Jesus through hearing, then saw him and reached out to touch him—successfully or not—the sensory progression here is from hearing to taste to sight. Listening to Jesus recite scriptural prooftexts isn't sufficient, it is only the embodied act of eating—a reenactment of their Last Supper together—that truly breaks the spell of misrecognition for the disciples.

The point is reinforced when they meet the other disciples. Jesus appears to the entire group, and struggles to reassure them he is not a ghost. "Look at my hands and my feet," he entreats them, "see that it is I myself. Touch me and see, for a ghost does not have flesh and bones as you see that I have" (Luke 24:39). Even this proves insufficient. Finally:

> While in their joy they were disbelieving and still wondering, he said to them, "Have you anything here to eat?" They gave him a piece of broiled fish, and he took it and ate in their presence. (Luke 24:41–43)

He might as well have said, "Hey, where can a guy get a bite to eat around here?" After all the profound signs Jesus has given them it is the casual, corporeal nature of this interchange that at last makes his presence real for the disciples. It's as if they have finally got their friend back, not *just* the messiah. Recognition seems to be a matter of sensing two aspects at once: the Everyman and the wholly Other.

If those who knew Jesus best in his lifetime had such a hard time spotting the resurrected Jesus when he was right next to them, it's natural to wonder whether anyone would be able to recognize him upon a second coming. Many artists, writers, and filmmakers have puzzled over this question, but Fyodor Dostoevsky offers a particularly thought-provoking example in his short story, "The Grand Inquisitor," contained within his sprawling masterpiece, *The Brothers Karamazov*. Dostoevsky imagines Jesus seeing the pain of his people during the Inquisition and being unable to stop himself from walking amid them to offer solace.

> [Jesus] has appeared quietly, unostentatiously, and yet—strange, this—everyone recognizes Him. . . . He passes among them with a quiet smile of infinite compassion. The sun of love burns in his heart, the

> beams of Light, Enlightenment and Power flow from
> his eyes and, as they stream over people, shake
> their hearts with answering love.

Dostoevsky's portrait evokes a similar duality we
observed in his appearance to the disciples at Emmaus.
Here again he is familiar yet strange, modest yet other-
worldly. But Dostoevsky's story also introduces another
key theme for our inquiry. When Jesus meets the epon-
ymous Grand Inquisitor, the latter is far from happy to
see him. He curtly informs Jesus that he is an unwelcome
intruder in the proper business of the church, which
is doing just fine—indeed better—without him. Jesus
might be brimming with abounding love, the Inquisitor
concedes, but he seriously overrates humanity's capacity
for freedom and moral self-determination. People need
subsistence and direction, he argues, far more than the
free will and love proffered by Jesus. In effect, the Grand
Inquisitor argues, Jesus has forfeited the copyright to his
own image. While we hardly need to take the Inquis-
itor's side—he literally plays the devil's advocate!—his
provocations lead to important questions: Who claims
the right to represent Jesus today? How do the powerful
and the powerless represent him differently? And how,

and in whom, should we recognize him amid a flurry of (mis)representations?

There are myriad answers to each of these questions. But it is useful to remember that Jesus is often hiding in plain sight, in the faces of the persecuted and the disinherited, to return to Thurman's phrase. In the modern period, various communities—whether Christian or not—have claimed Jesus as a symbol of their suffering. During the Holocaust, and in its aftermath, for instance, scores of Jewish artists identified the face of Jesus in European Jewry, driven to the brink of annihilation. Among these artists, Marc Chagall stands out for his repeated—even obsessive—depiction of the crucifixion, which appears in hundreds of works, most famously *White Crucifixion* (1938). Rather than a Christian Christ whose suffering redeems, Chagall's Jesus—a *tallit* or prayer shawl wrapped around his loins—is an innocent Jew suffering without any cause or higher purpose (figure 7). In his desperation to awaken the Christian world to the existential threat of antisemitism, Chagall addresses Christians in their own language, as if daring them to look away.

Today, some of the most powerful and urgent evocations of Jesus have emerged from African American

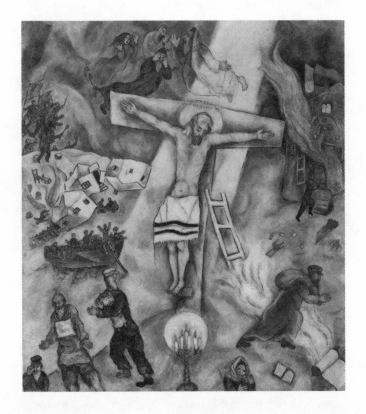

artists expressing moral outrage over what Eddie Glaude Jr. calls the "value gap" between Black and white lives in America. "Precious ideas like 'all men are created equal,'" writes Glaude, "were congenitally deformed by the idea that some men and women are valued less than others because of the color of their skin. The value gap was baked into one of the foundational principles of this country." In the visage of Jesus, Black artists have found

an iconography capable of both articulating this oppres-
sion and restoring dignity to its subjects.

This comes out poignantly in a recent series of photo-
graphs by Jared Thorne, titled *In the Wake* (figure 8). The
works originate in images drawn from autopsy reports
released by the families of unarmed Black men killed
by police officers. One such piece memorializes Laquan
McDonald, a Black teenager who was walking away
from Chicago police in 2014 when he was shot sixteen
times by an officer, who was later convicted of murder
on the basis of video footage suppressed by authori-
ties. Thorne's photogram of McDonald's autopsy report
shines a light on the brutality of the young man's exe-
cution. Moreover, by reversing the color of the original
white document, turning it black in the photogram,
Thorne underscores the stark reality of a system that tar-
gets bodies of color. The emblematic body of the autopsy
diagram—represented by a Caucasian face, another act
of erasure—is sketched as it would be examined, splayed
naked upon a table. We are invited to attend to each
bullet hole like the stigmata of the crucified Christ. Or
even to imagine ourselves in the position of Joseph of
Arimathea and Nicodemus, who tenderly prepare Jesus's
body for entombment (John 19:38–42). As James Cone
reminds us in *The Cross and the Lynching Tree*, drawing

the anguish of Jesus into the present does not diminish the power and sanctity of the archetype. Quite the opposite. It "frees the cross from the false pieties of well-meaning Christians . . . keep[ing] the cross from becoming a symbol of abstract, sentimental piety." Recognizing the "the crucified bodies in our midst"—as

Thorne's images impel us to do—provides a renewed opportunity to "encounter the real scandal of the cross."

VANTAGE POINTS

We have covered a lot of distance in this chapter. We began by considering how Jesus encourages us look at others in a way that allows them to be, and become, themselves before our eyes. In the next section, we explored how Jesus reveals the difference between pity and mercy, suggesting how we might learn to look others—even at their lowest points—directly in the eyes. Finally, we turned our attention to cases of misrecognition, in which our preconceptions and prejudices lead us to miss the Other right in front of us.

While we spent much of this book looking *through* Jesus's eyes, in the end we found ourselves looking *into* those eyes, from the vantage point of those closest to him. As Jesus prepared to take his final leave of his followers, we found that his lessons grew ever more direct. He modeled how to look at others by showing them how to look at himself, as if for the first time. With this glimpse of the risen Christ, we thus arrived at the outer perimeter of our inquiry, at the entry point to a territory best surveyed by believers.

As a Jew, I found this to be one of the more challeng-
ing sections of this book to write, and it was helpful to
arrive at this peak last, having made camp first at lower
elevations. It is one thing, of course, to write about the life
and teachings of Jesus—suffused in so many ways with
insights drawn from his Jewish identity and practices—
and quite another to write about the resurrected Christ.

I am reminded of Chagall's experience designing a
series of tiles and bas-reliefs for the Church of Notre-
Dame de Toute Grâce in Assy, in the French Alps. As
honored as he was by the commission from Father
Marie-Alain Couturier, the artist was beset by doubts in
the project's final stages. The fact that his works were des-
tined for the walls of the church's baptistery—the very
site at which people would be received into the Catho-
lic Church—seemed to make him particularly uneasy.
Would people read his panoramic scene of Exodus, in
which Jesus hovers above Moses, as the testimony of a
convert, or a warrant for supersessionism? Even after
he had finished glazing his tiles, the artist delayed their
firing, consigning them to the kiln only after adding a
short but revealing proviso: *Au nom de la liberté de toutes
les religions*, "In the name of the liberty of all religions."
I have held a similar sentiment in my mind in this book.
The deeper I have traveled into the Gospels, the more

aware I have felt of my Jewishness, and the greater the obligation I have felt to be clear about my intentions.

As I sensed myself approaching my limit, the place where theological inquiry passes the baton to personal faith, my wife, an Episcopal priest, asked me a question that helped put this project into perspective. She wasn't interested in whether I had come to believe in Jesus through this book. That answer is obvious (at least to her). Instead, she asked, "Do you *recognize* Jesus better now, at the end of the book, than you did at the start?" This goes straight to the heart of the matter. And as is often the case with good questions, it can't be answered by a simple yes or no.

In the past, I mainly found myself researching specific passages in the Gospels in order to contextualize creative works, or dipping into the lectionary with my wife as she prepared her Sunday sermons. Writing this book meant living much more closely and continuously with the texts of the Gospels, including passages that are hard to visualize or sermonize on. This process gave me a much more granular, textured sense of how Jesus looked at the world and the people in it—something I certainly hope I have conveyed to readers. *This* Jesus I came to recognize more and more.

Yet I also found myself struck, more often than I expected, by the strangeness of Jesus's vision in the

Gospels: the way in which he upends conventions of looking, within his own context as well as ours. I found a Jesus willing to take unorthodox leaps of faith and reason in order to destabilize ethical sureties and easy pieties. This Jesus, more eagle-eyed, unpredictable, and brilliant than I expected, was not someone I recognized initially, and he still continues to surprise me.

Ultimately, the enduring capacity of Jesus to stun and befuddle is a revelation in its own right. As clear as he can be at times—especially regarding how we should regard others—it seems that the Jesus of the Gospels does not want to be, or will not allow himself to be, completely recognizable. With uncanny foresight, Jesus not only avoided the full comprehension of his peers, he took evasive maneuvers for the future, many of which remain effective to this day. Our inquiry into how Jesus would see the world today must remain subjunctive, speculative.

This is hardly a defeat. As the poet Osip Mandelstam once said of Dante's cantos, one can't read the Gospels "without aiming them in the direction of the present day. They were made for that." But the Gospels are no almanac, and Jesus is no weatherman. His long-range forecast is both urgent and indeterminate. He invites us to look closely with him, to extend his insights into ever-new periods and contexts. But the responsibility remains with us to fill in the picture.

FRONT MATTER

Amichai, Yehuda. "Gods Change, Prayers Are Here to Stay." In *Open Closed Open: Poems*. Translated by Chana Bloch and Chana Kronfeld. Orlando: Harcourt, 2000.

Cohen, Leonard. "Suzanne." Track 1 on *Songs of Leonard Cohen*. Columbia Records, 1967.

Wilde, Oscar. *De Profundis and Other Writings*. London: Penguin Books, 1986.

INTRODUCTION

Aslan, Reza. *Zealot: The Life and Times of Jesus of Nazareth*. New York: Random House, 2013.

Buber, Martin. *Two Types of Faith*. Translated by N. P. Goldhawk. New York: Macmillan, 1951.

Crossan, John Dominic. *The Historical Jesus: The Life of a Mediterranean Jewish Peasant*. New York: HarperOne, 1993.

Crossley, James G. *Jesus in an Age of Neoliberalism: Quests, Scholarship and Ideology*. New York: Routledge, 2014.

Deggans, Eric. "'This Little Light of Mine' Shines On, a Timeless Tool of Resistance." WBUR. August 6, 2018. https://tinyurl.com/yvpd6p84.

Ehrman, Bart. *Jesus: Apocalyptic Prophet of the New Millennium*. Oxford: Oxford University Press, 1999.

Heschel, Susannah. *Abraham Geiger and the Jewish Jesus.* Chicago: University of Chicago Press, 1998.

Joyce, Paul M., and Diana Lipton. *Lamentations through the Centuries.* Chichester, UK: Wiley-Blackwell, 2013.

Kafka, Franz. *The Diaries of Franz Kafka, 1910–1923.* Edited by Max Brod. Translated by Joseph Kresh, Martin Greenberg, and Hannah Arendt. New York: Schocken Books, 1988.

King, Martin Luther, Jr. *Strength to Love.* Minneapolis: Fortress Press, 2010.

Morisette, Alanis. "Ironic." Track 10 on *Jagged Little Pill.* Maverick Recording Company, 1995.

Potok, Chaim. *My Name Is Asher Lev.* London: Penguin Books, 1973.

Quash, Ben. *Found Theology: History, Imagination, and the Holy Spirit.* London: Bloomsbury, 2013.

Rosen, Aaron. *Imagining Jewish Art: Encounters with the Masters in Chagall, Guston, and Kitaj.* London: Routledge, 2020.

Stendahl, Krister. *Paul among Jews and Gentiles and Other Essays.* Philadelphia: Fortress Press, 1976.

Yeats, W. B. "The Second Coming." In *The Collected Poems of W. B. Yeats.* London: Wordsworth Editions, 2008.

CHAPTER 1

Carter, Jimmy. "The Playboy Interview with Jimmy Carter." Interviewed by Robert Scheer. *Playboy*, November 1, 1976. https://tinyurl.com/2xmyb9h8.

Fletcher, Michelle. Personal correspondence. May 12, 2022.

Kieffer, René. "John." In *The Oxford Bible Commentary*, edited by John Barton and John Muddiman. Oxford: Oxford University Press, 2008.

Locke, John. *An Essay Concerning Human Understanding.* Edited by Kenneth Winckler. Indianapolis: Hackett Publishing Company, 1996.

Merleau-Ponty, Maurice. "The Intertwining—the Chiasm." Translated by Alphonso Lingis in *Merleau-Ponty: Basic Writings*, edited by Thomas Baldwin. London: Routledge, 2004.

Morgan, David. *The Sacred Gaze: Religious Visual Culture in Theory and Practice.* Berkeley: University of California Press, 2005.

Ott, Martin. "Drawing Near." *The Visual Commentary on Scripture.* https://tinyurl.com/scumrrr9.

Plate, S. Brent. *A History of Religion in 5 1/2 Objects: Bringing the Spiritual to Its Senses.* Boston: Beacon Press, 2014.

Quash, Ben, and Jennifer Sliwka, "The Transfiguration." Video commentary. *The Visual Commentary on Scripture*, https://tinyurl.com/yesbx82e.

Spivak, Gayatri Chakravorty, "Can the Subaltern Speak?" In *Marxism and the Interpretation of Culture*, edited by Cary Nelson and Lawrence Grossberg. Champaign: University of Illinois Press, 1988.

Steinberg, Leo. *The Sexuality of Christ in Renaissance Art and in Modern Oblivion.* Chicago: University of Chicago Press, 1996.

Taylor, Joan. *What Did Jesus Look Like?* London: Bloomsbury/T&T Clark, 2018.

Williams, Rowan. *Writing in the Dust: Reflections on 11th September and Its Aftermath*. London: Hodder & Stoughton, 2002.

CHAPTER 2

Cash, Johnny. "The Man Comes Around." Track 1 on *American IV: The Man Comes Around*. American Recording Company, 2002.

Dickens, Charles. *Night Walks and Other Essays*. Bristol: Read & Co. Books, 2020.

Eliade, Mircea. *The Sacred and the Profane: The Nature of Religion*. Translated by Willard Trask. Orlando: Harcourt, 1987.

Eliot, T. S. "The Waste Land." In *The Waste Land and Other Poems*. London: Faber and Faber, 1990.

Gent, Edd. "The Plight of Japan's Modern Hermits." BBC, January 29, 2019. https://tinyurl.com/5h4pne32.

Gilio-Whitaker, Dina. *As Long as Grass Grows: The Indigenous Fight for Environmental Justice, from Colonization to Standing Rock*. Boston: Beacon Press, 2019.

Homrighausen, Jonathan. Personal correspondence. June 4, 2022.

John, Tara. "How the World's First Loneliness Minister Will Tackle 'the Sad Reality of Modern Life.'" *Time*, April 25, 2018.

Kahneman, Daniel. *Thinking, Fast and Slow*. New York: Farrar, Straus and Giroux, 2011.

Krinke, Rebecca. "Nature, Healing, and the Numinous." In *Transcending Architecture: Contemporary Views on Sacred*

Space, edited by Julio Bermudez. Washington, DC: Catholic University of America Press, 2015.

The Last Dance. Directed by Jason Hehir. ESPN Films and Netflix, 2020.

Mailer, Norman. *The Gospel according to The Son: A Novel*. New York: Random House, 1997.

Mann, Thomas. *Joseph and His Brothers*. Translated by John E. Woods. New York: Everyman's Library, 2005.

Marshall, George. *Don't Even Think about It: Why Our Brains Are Wired to Ignore Climate Change*. London: Bloomsbury, 2015.

McKibben, Bill. *The Bill McKibben Reader: Pieces from an Active Life*. New York: Henry Holt & Co., 2008.

McPhee, Laura. *A Journey into Matisse's South of France*. Berkeley: Roaring Forties Press, 2010.

Merton, Thomas. *Thoughts in Solitude*. New York: Farrar, Straus and Giroux, 1999.

Moltmann, Jürgen. *Theology of Hope: On the Ground and the Implications of a Christian Eschatology*. New York: Harper & Row, 1975.

Murphy, Kate. "How to Rearrange Your Post-Pandemic 'Friendscape.'" *New York Times*, June 1, 2021. https://tinyurl.com/yc8ys898.

Murthy, Vivek, and Pooja Kumar. "Avoiding a 'Social Recession': A Conversation with Vivek Murthy." McKinsey.com. June 9, 2020. https://tinyurl.com/5sxmda2n.

Nouwen, Henri J. M. *The Wounded Healer: Ministry in Contemporary Society*. New York: Doubleday, 1979.

Prime Minister's Office. "PM Launches Government's First Loneliness Strategy." Press release, *Gov.uk*. October 15, 2018. https://tinyurl.com/4kpjjkmt.

Putnam, Robert. *Bowling Alone: The Collapse and Revival of American Community.* New York: Simon & Schuster, 2000.

R.E.M. "It's the End of the World As We Know It (and I Feel Fine)." Track 6 on *Document*. I.R.S. Records, 1987.

Reynolds, Gretchen. "An 'Awe Walk' Might Do Wonders for Your Well-Being." *New York Times*, September 30, 2020. https://tinyurl.com/y8c3v9dt.

Taylor, Dorceta. *Toxic Communities: Environmental Racism, Industrial Pollution, and Residential Mobility.* New York: New York University Press, 2014.

Thoreau, Henry David. *The Natural History Essays.* Edited by Robert Sattelmeyer. Salt Lake City: Peregrine Smith, 1980.

Turner, Edith, and Victor Turner. *Image and Pilgrimage in Christian Culture.* New York: Columbia University Press, 1978.

Weil, Simone. *Gravity and Grace.* Translated by Arthur Wills. Lincoln, NE: Bison Books, 1997.

CHAPTER 3

Arendt, Hannah. *The Portable Hannah Arendt.* Edited by Peter Baehr. New York: Penguin Books, 2003.

Berger, John. *Ways of Seeing.* London: Penguin, 1972.

The Colbert Report. Season 1, episode 1. Comedy Central, 2005.

Didi-Huberman, Georges. *Bark*. Translated by Samuel E. Martin. Cambridge, MA: MIT Press, 2017.

Dominioni, Irene. "Things a Single Photo Can Do: How Chiara Ferragni Prompted Debate on the Cultural Sector in Italy." *Forbes*, July 30, 2020. Accessed 1 October 2020. https://tinyurl.com/yck4ytku.

Gray, Howard. "Ignatian Spirituality." In *An Ignatian Spirituality Reader*, edited by George W. Traub. Chicago: Loyola Press, 2008.

Gunter, Joel. "'Yolocaust': How Should You Behave at a Holocaust Memorial?" BBC, January 20, 2017. https://tinyurl.com/6rku4jzs. Accessed 23 July 2021.

Ignatius of Loyola, Saint. *The Spiritual Exercises of Saint Ignatius*. Translated by George E. Ganss. Chicago: Loyola Press, 1992.

Jiménez, Jesus, and Claire Fahy. "Missouri Man Is Exonerated in 3 Killings after 43 Years in Prison." *New York Times*, November 23, 2021. https://tinyurl.com/4yj38y2a.

Kierkegaard, Søren. *Fear and Trembling*. Edited by C. Stephen Evans and Sylvia Walsh. Translated by Sylvia Walsh. Cambridge: Cambridge University Press, 2006.

Maimonides, Moses. *A Maimonides Reader*. Edited by Isadore Twersky. Springfield, NJ: Behrman House, Inc., 1972.

Monty Python's Life of Brian. Directed by Terry Jones. Handmade Films, 1979.

Pew Research Center. *Religious Landscape Survey*. Accessed August 22, 2021. https://tinyurl.com/yc3kenxd.

Ronson, Jon. *So You've Been Publicly Shamed*. New York: Riverhead Books, 2015.

Russonello, Giovanni. "QAnon Now as Popular in U.S. as Some Major Religions, Poll Suggests." *New York Times*, May 27, 2021. https://tinyurl.com/3thk7ded.

Shapira, Shahak, "YOLOCAUST." https://yolocaust.de/. Accessed July 23, 2021.

Sontag, Susan. *On Photography*. New York: Picador, 1977.

Thomas Aquinas. *A Summa of the Summa*. Edited by Peter Kreeft. San Francisco: Ignatius Press, 1990.

Traub, Alex. "1955 Arrest Warrant in Emmett Till Case Is Found in Court Basement." *New York Times*, June 30, 2022.

The Oxford English Dictionary, 3rd ed. Oxford: Oxford University Press, 2015.

Wehner, Peter. "Will Christian America Withstand the Pull of QAnon?" *New York Times*, June 18, 2021. https://tinyurl.com/mr3w4kd3.

CHAPTER 4

Buber, Martin. *I and Thou*. Translated by Walter Kaufmann. New York: Charles Scribner's Sons, 1970.

Cone, James. *The Cross and the Lynching Tree*. Maryknoll, NY: Orbis Books, 2013.

Dostoevsky, Fyodor. *The Brothers Karamazov*. London: Penguin Books, 2003.

Fields, Barbara J., and Karen E. Fields. *Racecraft: The Soul of Inequality in American Life*. New York: Verso, 2012.

Glaude, Eddie. *Democracy in Black: How Race Still Enslaves the American Soul*. New York: Crown Publishers, 2016.

Holcombe, Madeline. "Black and White Friends Try to Trick Teacher with Matching Haircuts." CNN, March 3, 2017. https://tinyurl.com/2p9h6dn2.

Homrighausen, Jonathan. *Planting Letters and Weaving Lines: Calligraphy, The Song of Songs, and* The Saint John's Bible. Collegeville, MN: Liturgical Press, 2022.

Kipling, Rudyard. "The White Man's Burden: The United States & The Philippine Islands, 1899." In *The Collected Poems of Rudyard Kipling*. Ware, UK: Wordsworth Editions, 2001.

Mandelstam, Osip. "Conversations about Dante." In *The Selected Poems of Osip Mandelstam*. Translated by Clarence Brown and W. S. Merwin. New York: New York Review of Books, 2004.

Olin, Margaret. *The Nation without Art: Examining Modern Discourses on Jewish Art*. Lincoln: University of Nebraska, 2001.

Rose, Gillian. *Love's Work*. New York: New York Review of Books Classics, 2011.

Rosen, Aaron. *Imagining Jewish Art: Encounters with the Masters in Chagall, Guston, and Kitaj*. London: Routledge, 2020.

Rubin, William. *Modern Sacred Art and the Church of Assy*. New York: Columbia University Press, 1961.

Salcedo, Andrea, "A Christian Teacher Was Suspended for Refusing to Call Students by the Pronouns They Use.

Now She Is Suing." *Washington Post*, March 15, 2022. https://tinyurl.com/2cp2uyx6.

Schrader, Elizabeth, and Brandon Simonson. "'Rabbouni,' Which Means Lord: Narrative Variants in John 20:16." *TC: A Journal of Biblical Textual Criticism* 26 (2022).

Thurman, Howard. *Jesus and the Disinherited*. Boston: Beacon Press, 1996.

Wilde, Oscar. *De Profundis and Other Writings*. London: Penguin Books, 1986.

Figure 1 (page 35). Roger Wagner (b. 1957), *Writing in the Dust*, 2016, oil on canvas, 31.3 x 38.8 cm. Collection: The Faith Museum, Auckland Castle. © The artist.

Figure 2 (page 48). Theophanes the Greek and Workshop (ca. 1340–ca. 1410), *The Transfiguration*, early fifteenth century, tempera on wood, 184 x 134 cm. Collection: The Tretyakov Gallery.

Figure 3 (page 108). Ndume Olatushani (b. 1958), *Disrupting the Cradle to Prison Pipeline*, 2017. © The artist. Photo © Elvert Barnes, licensed under CC BY-SA 2.0: https://creativecommons.org/licenses/by-sa/2.0/.

Figure 4 (page 110). Michelangelo Merisi de Caravaggio (1571–1610), *The Incredulity of Saint Thomas*, ca. 1601–1602, oil on canvas, 107 x 146 cm. Collection: Sanssouci Picture Gallery.

Figure 5 (page 139). Michelangelo Merisi de Caravaggio (1571–1610), *The Calling of Saint Matthew*, ca. 1599–1600, oil on canvas, 322 cm x 340 cm. Collection: San Luigi dei Francesi, Rome.

Figure 6 (page 158). Titian (ca. 1506–1576), *Noli me Tangere*, ca. 1514, oil on canvas, 110.5 x 91.9 cm. Collection: The National Gallery. Bequeathed by Samuel Rogers, 1856, NG270 © The National Gallery, London.

Figure 7 (page 164). Marc Chagall (1887–1985), *White Crucifixion*, 1938, oil on canvas, 154.6 x 140 cm. Collection: Art Institute of Chicago. Gift of Alfred S. Alschuler, 1946.925 © 2022 Artists Rights Society (ARS), New York / ADAGP, Paris.

Figure 8 (page 166). Jared Thorne (b. 1981), *Laquan McDonald* (from the series *In the Wake*), 2019, silver gelatin print, 50.8 x 60.96 cm. © The artist.

ACKNOWLEDGMENTS

This book has been bubbling in the back of my mind for a long time. I can trace some of the questions in it to classes I took in university with inspirational biblical scholars including Nicola Denzey and Diana Lipton. And there are sources and ideas I fondly recall discussing with my beloved mentor and doctoral supervisor, Graham Howes (z"l), in his attic study in Cambridge. He would have chuckled heartily at the thought of me writing a book about Jesus. There are also a great many insights from colleagues over the years sprinkled through this text, including chats with Ben Quash and Joan Taylor at King's College London, as well as Sathianathan Clarke, Laura Holmes, and Devon Abts at Wesley Theological Seminary, and *Image Journal* compatriots James K. A. Smith and Lauren Winner. I emailed and rang up many scholars, clergy, curators, and artists for specific advice along the way—too many to name here—but I'm particularly grateful for those friends who assiduously sifted through drafts and offered

feedback, including Anthony Apodaca, Chuck Borek, Michelle Fletcher, Travis Helms, Jonathan Homrighausen, Michael Takeo Magruder, and Michael Runyon. I particularly want to thank my commissioning editor at Broadleaf, Lil Copan, without whom this book would have remained on the back burner indefinitely. It was Lil who encouraged me to pitch this book in the first place, and had a curiously unwavering belief that other people might be interested in what a Jewish theologian with a specialty in visual culture might have to say about Jesus.

NOTES

EPIGRAPHS

The faith that others give to what is unseen: Oscar
 Wilde, *De Profundis and Other Writings* (Lon-
 don: Penguin, 1986), 154.

I don't want an invisible god: Yehuda Amichai,
 "Gods Change, Prayers Are Here to Stay," in
 Open Closed Open: Poems, trans. Chana Bloch
 and Chana Kronfeld (Orlando: Harcourt, 2000).

And Jesus was a sailor: Leonard Cohen, "Suzanne," track 1
 on *Songs of Leonard Cohen*, Columbia Records, 1967.

INTRODUCTION

By opening our lives to God in Christ: Martin Luther King
 Jr., *Strength to Love* (Minneapolis: Fortress Press, 2010),
 17.

It's a black fly in your Chardonnay: Alanis Morissette,
 "Ironic," track 10 on *Jagged Little Pill*, Maverick Record-
 ing Company, 1995.

It shook the Nazis: Eric Deggans, "'This Little Light of
 Mine' Shines On, a Timeless Tool of Resistance,"
 WBUR. August 6, 2018, https://tinyurl.com/yvpd6p84.

My own intention is not to paint another portrait: James
 G. Crossley helpfully summarizes this smorgasbord of
 scholarly offerings:

 We have not only a Cynic-like figure, an escha-
 tological prophet, a rabbi, a wisdom teacher,

charismatic holy man and so on, but all sorts of combinations which are now being touted by major historical Jesus scholars: Jewish peasant cynic, wisdom teacher *and* eschatological prophet, charismatic holy rabbi, challenger of traditional gender categories *and* social critic and so on. And if *your* Jesus isn't here, one can easily be made up for you, or another category can always be added! (James G. Crossley, *Jesus in an Age of Neoliberalism: Quests, Scholarship and Ideology* [New York: Routledge, 2014], 93)

Many of the portraits noted or anticipated by Crossley have gained public attention in recent years, from John Dominic Crossan on Jesus as a Mediterranean Jewish peasant to Bart Ehrman's Jesus as apocalyptic prophet, or Reza Aslan's depiction of Jesus as zealot, to name just a few titles. Frequently, media attention has circled around the religious commitments—or lack thereof—of the authors, or fostered false controversies based on their allegedly heretical claims. The Fox News–sponsored furor around Aslan's book was instructive on both accounts, as it made worrying assumptions based on his identity as a Muslim, while also turning Aslan's rather familiar thesis that Jesus was a political revolutionary into something far more radical than it was.
Rather than offering a "reception history": Paul M. Joyce and Diana Lipton, *Lamentations through the Centuries* (Chichester, UK: Wiley-Blackwell, 2013), 18.

In God, human beings are constantly invited: Ben Quash,
 Found Theology: History, Imagination, and the Holy Spirit
 (London: Bloomsbury, 2013), xiv.

What have I in common with Jews?: Franz Kafka, *The
 Diaries of Franz Kafka, 1910–1923*, ed. Max Brod, trans.
 Joseph Kresh, Martin Greenberg, and Hannah Arendt
 (New York: Schocken Books, 1988), 252.

How, I started to ask, could a modern Jewish artist: Aaron
 Rosen, *Imagining Jewish Art: Encounters with the Masters
 in Chagall, Guston, and Kitaj* (London: Routledge, 2020).

Asher Lev, you want to go off into a corner: Chaim Potok,
 My Name Is Asher Lev (London: Penguin Books,
 1973), 199.

What Susannah Heschel calls: Susannah Heschel, *Abraham
 Geiger and the Jewish Jesus* (Chicago: University of Chi-
 cago Press, 1998), 1.

From my youth onwards: Martin Buber, *Two Types of Faith*,
 trans. N. P. Goldhawk (New York: Macmillan, 1951), 12.

Just as Christians in every generation: Heschel, *Abraham
 Geiger and the Jewish Jesus*, 4.

And, just as importantly, I wanted to write: If I'm success-
 ful in that endeavor, I owe significant thanks to my
 co-leader in those gatherings, Mike Armstrong, a Meth-
 odist pastor who encouraged me to find my own spiritual
 voice with students, rooted in my own religious identity
 and more equivocal approach to faith.

I have become even more convinced: Krister Stendahl, *Paul
 among Jews and Gentiles and Other Essays* (Philadelphia:
 Fortress Press, 1976), viii.

Turning and turning in the widening gyre: W. B. Yeats, "The
Second Coming," in *The Collected Poems of W. B. Yeats*
(London: Wordsworth Editions, 2008), 158.

CHAPTER 1

Bringing the spiritual to its senses: S. Brent Plate, *A History
of Religion in 5 1/2 Objects: Bringing the Spiritual to Its
Senses* (Boston: Beacon Press, 2014), 7.

Not shameful, but literally: Leo Steinberg, *The Sexuality of
Christ in Renaissance Art and in Modern Oblivion* (Chi-
cago: University of Chicago Press, 1996), 24.

I should feel defeated: Steinberg, *The Sexuality of Christ*, 24.

While the Gospels don't tell us: See chapter 3 for a discussion
of Jesus's reference to whitewashed tombs.

I am guided in this work: David Morgan, *The Sacred Gaze:
Religious Visual Culture in Theory and Practice* (Berkeley:
University of California Press, 2005), 3.

I've looked on a lot of women: Jimmy Carter, "The Playboy
Interview with Jimmy Carter," interviewed by Robert
Scheer, *Playboy*, November 1, 1976.

Since the same body sees and touches: Maurice Merleau-
Ponty, "The Intertwining—the Chiasm," trans. Alphonso
Lingis in *Merleau-Ponty: Basic Writings*, ed. Thomas
Baldwin (London: Routledge, 2004), 252.

Vision is a palpation with the look: Merleau-Ponty, "The
Intertwining—the Chiasm," 252.

It's also worth noting that the episode is a late addition: René
Kieffer, "John," in *The Oxford Bible Commentary*, ed. John

Barton and John Muddiman (Oxford: Oxford University Press, 2008), 999.

Instead of yielding to the throng's thirst: Rowan Williams, *Writing in the Dust: Reflections on 11th September and Its Aftermath* (London: Hodder & Stoughton, 2002), 80–81.

Something filmic renderings tend to neglect: Michelle Fletcher, personal correspondence, May 12, 2022.

Which allows the subaltern to speak: Gayatri Chakravorty Spivak, "Can the Subaltern Speak?," in *Marxism and the Interpretation of Culture*, ed. Cary Nelson and Lawrence Grossberg (Champaign: University of Illinois Press, 1988), 271.

Locke correctly theorized: John Locke, *An Essay Concerning Human Understanding*, ed. Kenneth Winckler (Indianapolis: Hackett Publishing Company, 1996), 58–59.

He is quite literally teaching: Artists have intuited this for centuries, depicting Jesus reaching out to guide the touch of the formerly blind man. See for example the Master of Santa María de Taüll, *The Healing of the Blind Man and the Raising of Lazarus*, ca. 1125, fresco, Ermita de San Baudelio de Berlanga, Caltojar, Soria, Spain (Martin Ott, "Drawing Near," *The Visual Commentary on Scripture*, https://tinyurl.com/scumrrr9).

There is one quite obvious reason: Joan Taylor, *What Did Jesus Look Like?* (London: Bloomsbury/T&T Clark, 2018), 155.

Because archaeology has enabled: Taylor, *What Did Jesus Look Like?*, 155.

All we know, explains my colleague Ben Quash: Ben
 Quash and Jennifer Sliwka, "The Transfiguration,"
 video commentary. *The Visual Commentary on Scripture*,
 https://tinyurl.com/yesbx82e.

CHAPTER 2
Political scientist Robert Putnam estimated: Robert Put-
 nam, *Bowling Alone: The Collapse and Revival of American
 Community* (New York: Simon & Schuster, 2000), 283.
Give people the power to build community: Face-
 book.com, "About," accessed May 1, 2022,
 https://tinyurl.com/3c84m2hz.
Newer testament,—the gospel according to this moment:
 Henry David Thoreau, *The Natural History Essays*, ed.
 Robert Sattelmeyer (Salt Lake City: Peregrine Smith,
 1980), 134.
Would that we were all Charles Dickens: Charles Dickens,
 Night Walks and Other Essays (Bristol: Read & Co.,
 2020).
The spiritual life is . . . first of all a matter of keeping awake:
 Thomas Merton, *Thoughts in Solitude* (New York: Farrar,
 Straus and Giroux, 1999), 39.
At Ireland's famous St. Patrick's Purgatory: Edith Turner and
 Victor Turner, *Image and Pilgrimage in Christian Culture*
 (New York: Columbia University Press, 1978), 121.
Attention which is so full: Simone Weil, *Gravity and Grace*,
 trans. Arthur Wills (Lincoln, NE: Bison Books, 1997),
 171.

Extreme attention is what constitutes the creative faculty:
Weil, *Gravity and Grace*, 170.

His contemporary Henri Matisse called his mindset: Laura
McPhee, *A Journey into Matisse's South of France* (Berkeley, CA: Roaring Forties Press, 2010), 193.

Like fragments shored against a future loss: T. S. Eliot, "The
Waste Land," in *The Waste Land and Other Poems* (London: Faber and Faber, 1990), 41.

Attention, taken to its highest degree: Weil, *Gravity and
Grace*, 170.

In an insightful interview, Vivek Murthy: Vivek Murthy
and Pooja Kumar, "Avoiding a 'Social Recession': A
Conversation with Vivek Murthy," McKinsey.com, June
9, 2020, https://tinyurl.com/5sxmda2n.

The UK government appointed its first minister of loneliness:
Prime Minister's Office, "PM Launches Government's
First Loneliness Strategy," press release, Gov.uk, October
15, 2018, https://tinyurl.com/4kpjjkmt.

The Japanese government appointed its own minister of loneliness: Edd Gent, "The Plight of Japan's
Modern Hermits," BBC, January 29, 2019,
https://tinyurl.com/5h4pne32.

"Friendscape," to use one researcher's cringey portmanteau: Kate Murphy, "How to Rearrange Your Postpandemic 'Friendscape,'" *New York Times*, June 1, 2021,
https://tinyurl.com/yc8ys898.

Jesus takes advantage of nighttime: Jonathan Homrighausen, personal correspondence, June 4, 2022.

It becomes almost painful to watch Jesus: e.g., Norman
 Mailer, *The Gospel according to the Son* (New York: Ran-
 dom House, 1997), 99.

One study revealed that the very same physical activity:
 Rebecca Krinke, "Nature, Healing, and the Numinous,"
 in *Transcending Architecture: Contemporary Views on
 Sacred Space*, ed. Julio Bermudez (Washington, DC:
 Catholic University of America Press, 2015), 48.

Both groups were asked to take a quick selfie on their walk:
 Gretchen Reynolds, "An 'Awe Walk' Might Do Wonders
 for Your Well-Being," *New York Times*, September 30,
 2020, https://tinyurl.com/y8c3v9dt.

Rachel Kaplan and Stephen Kaplan emphasize: Krinke,
 "Nature, Healing, and the Numinous," 48.

As they spoke the moon: Thomas Mann, *Joseph and His
 Brothers*, trans. John E. Woods (New York: Everyman's
 Library, 2005), 92.

As the phenomenologist Mircea Eliade notes: Mircea Eliade,
 The Sacred and the Profane: The Nature of Religion, trans.
 Willard Trask (Orlando: Harcourt, 1987), 36.

I am alarmed when it happens: Thoreau, *Natural History
 Essays*, 99.

As Dina Gilio-Whitaker, Dorceta Taylor, and other scholars:
 Dina Gilio-Whitaker, *As Long as Grass Grows: The Indig-
 enous Fight for Environmental Justice, from Colonization
 to Standing Rock* (Boston: Beacon Press, 2019); Dorceta
 Taylor, *Toxic Communities: Environmental Racism, Indus-
 trial Pollution, and Residential Mobility* (New York: New
 York University Press, 2014).

An image ominously evoked by Johnny Cash: Johnny Cash, "The Man Comes Around," track 1 on *American IV: The Man Comes Around,* American Recording Company, 2002.

The veteran climate campaigner George Marshall: George Marshall, *Don't Even Think about It: Why Our Brains Are Wired to Ignore Climate Change* (London: Bloomsbury, 2015); Daniel Kahneman, *Thinking, Fast and Slow* (New York: Farrar, Straus and Giroux, 2011).

"It's the end of the world as we know it": R.E.M., "It's the End of the World As We Know It (and I Feel Fine)," track 6 on *Document,* I.R.S. Records, 1987.

Thus hope and anticipations of the future: Jürgen Moltmann, *Theology of Hope: On the Ground and the Implications of a Christian Eschatology* (New York: Harper & Row, 1975), 25.

Speaks of Jesus Christ and his future: Moltmann, *Theology of Hope,* 17.

The creative "passion for the possible": Moltmann, *Theology of Hope,* 35.

The first great piece of nature writing in the Western tradition: Bill McKibben, *The Bill McKibben Reader: Pieces from an Active Life* (New York: Henry Holt & Co., 2008), 219.

The more I learned about the greenhouse effect: McKibben, *Bill McKibben Reader,* 190.

In an effort to explain just what separated: *The Last Dance,* directed by Jason Hehir (ESPN Films and Netflix, 2020).

Anyone who wants to pay attention without intention: Henri
J. M. Nouwen, *The Wounded Healer: Ministry in Contemporary Society* (New York: Doubleday, 1979), 90–91.

CHAPTER 3

The Truthiness is anyone can read the news to you: The Colbert Report, season 1, episode 1 (Comedy Central, 2005).

Truthfulness. Now rare: Oxford English Dictionary, 3rd
ed. (Oxford: Oxford University Press, 2015), s.v.
"Truthiness."

The liar, lacking the power: Hannah Arendt, *The Portable Hannah Arendt*, ed. Peter Baehr (New York: Penguin, 2003), 562–63.

The surest long-term result of brainwashing: Arendt, *Portable Hannah Arendt*, 568.

The powers of photography: Susan Sontag, *On Photography* (New York: Picador, 1977), 179.

St. Ignatius, the order's founder: St. Ignatius of Loyola, *The Spiritual Exercises of Saint Ignatius*, trans. George E.
Ganss (Chicago: Loyola Press, 1992).

In the act of discerning love: Howard Gray, "Ignatian Spirituality," in *An Ignatian Spirituality Reader*, ed. George W.
Traub (Chicago: Loyola Press, 2008), 69.

Where everybody lies about everything: Arendt, *Portable Hannah Arendt*, 564.

The image . . . makes [the consumer] envious of himself: John
Berger, *Ways of Seeing* (London: Penguin, 1972), 132.

A sort of contemporary divinity: Irene Dominioni, "Things a Single Photo Can Do: How Chiara Ferragni Prompted Debate on the Cultural Sector in Italy," *Forbes,* July 30, 2020, accessed October 1, 2020, https://tinyurl.com/yck4ytku.

The quoted work of art: Berger, *Ways of Seeing,* 135.

The Israeli-German writer and artist Shahak Shapira: Shahak Shapira, "YOLOCAUST," https://yolocaust.de/, accessed July 23, 2021.

It's like a Catholic church: Joel Gunter, "'Yolocaust': How Should You Behave at a Holocaust Memorial?" BBC News, January 20, 2017, https://tinyurl.com/6rku4jzs.

As Jon Ronson explores: Jon Ronson, *So You've Been Publicly Shamed* (New York: Riverhead, 2015).

Recently, investigators unearthed an unserved warrant: Alex Traub, "1955 Arrest Warrant in Emmett Till Case Is Found in Court Basement," *New York Times,* June 30, 2022.

Had been convicted despite a lack of physical evidence: Jesus Jiménez and Claire Fahy, "Missouri Man Is Exonerated in 3 Killings after 43 Years in Prison," *New York Times,* November 23, 2021, https://tinyurl.com/4yj38y2a.

Kierkegaard readily admits: Søren Kierkegaard, *Fear and Trembling,* ed. C. Stephen Evans and Sylvia Walsh, trans. Sylvia Walsh (Cambridge: Cambridge University Press, 2006), 58.

The ultimate place of the absence of witnesses: Georges
Didi-Huberman, *Bark*, trans. Samuel E. Martin (Cambridge, MA: MIT Press, 2017), 93.

Aquinas asserted that beyond its literal sense: Thomas
Aquinas, *A Summa of the Summa*, ed. Peter Kreeft (San
Francisco: Ignatius Press, 1990).

As someone who celebrated the complexity of parables: Moses
Maimonides, *A Maimonides Reader*, ed. Isadore Twersky
(Springfield, NJ: Behrman House, 1972), 237–39.

It is not the purpose of this treatise to make its totality understandable: Maimonides, *Guide for the Perplexed*, 236.

You should not think that these great secrets: Maimonides,
Guide for the Perplexed, 238.

14 percent of Americans: Giovanni Russonello, "QAnon
Now as Popular in U.S. as Some Major Religions,
Poll Suggests," *New York Times*, May 27, 2021,
https://tinyurl.com/3thk7ded; Pew Research Center,
Religious Landscape Survey, https://tinyurl.com/yc3kenxd.

***While one might hope the church would have an inoculative
effect:*** Peter Wehner, "Will Christian America Withstand the Pull of QAnon?," *New York Times*, June 18,
2021, https://tinyurl.com/mr3w4kd3.

Brian: Look, you've got it all wrong!: *Monty Python's Life of
Brian*, directed by Terry Jones (Handmade Films, 1979).

CHAPTER 4

To their delight, the teacher played along with the boys' caper:
Madeline Holcombe, "Black and White Friends Try to

Trick Teacher with Matching Haircuts," CNN, March 3, 2017, https://tinyurl.com/2p9h6dn2.

Came into existence at a discernible historical moment: Barbara J. Fields and Karen E. Fields, *Racecraft: The Soul of Inequality in American Life* (New York: Verso, 2012), 121.

In a highly allusive, poetic style: Margaret Olin, *The Nation without Art: Examining Modern Discourses on Jewish Art* (Lincoln: University of Nebraska, 2001), 104.

According to Buber, Jesus is preeminently gifted: Martin Buber, *I and Thou*, trans. Walter Kaufmann (New York: Charles Scribner's Sons, 1970), 116.

Feelings one "has"; love occurs: Buber, *I and Thou*, 66.

Ms. Ricard [the teacher] believes: "A Christian Teacher Was Suspended for Refusing to Call Students by the Pronouns They Use. Now She Is Suing," *Washington Post*, March 15, 2022, https://tinyurl.com/2cp2uyx6.

In a manner not yet understood of the world: Wilde, *De Profundis*, 178.

Behind sorrow there is always sorrow: Wilde, *De Profundis*, 161.

Wilde refers to Christ's life as "a work of art": Wilde, *De Profundis*, 179.

It is exceedingly difficult to hold oneself free: Howard Thurman, *Jesus and the Disinherited* (Boston: Beacon Press, 1996), 2–3.

"The White Man's Burden": Rudyard Kipling, "The White Man's Burden: The United States & The Philippine

Islands, 1899," in *The Collected Poems of Rudyard Kipling* (Ware, UK: Wordsworth Editions, 2001), 334.

I grew up with this interpretation: Thurman, *Jesus and the Disinherited*, 82–83.

A common sharing of a sense of mutual worth and value: Thurman, *Jesus and the Disinherited*, 88.

Nowhere is this more compelling: Wilde, *De Profundis*, 175.

Had the power of not merely saying beautiful things himself: Wilde, *De Profundis*, 175.

Love is a sacrament that should be taken kneeling: Wilde, *De Profundis*, 175.

[Jesus's response] had in it all the deep frustration: Thurman, *Jesus and the Disinherited*, 81.

With their backs against the wall: Thurman, *Jesus and the Disinherited*, 1.

But it is an instructive reminder that love does not occur: I am reminded of the words of the philosopher Gillian Rose, who put it perfectly in her memoir, as she was dying of cancer: "There is no democracy in any love relation: only mercy. To be at someone's mercy is dialectical damage: they may be merciful and they may be merciless." Gillian Rose, *Love's Work* (New York: New York Review of Books Classics, 2011), 60.

Other works, including medieval manuscripts, sometimes show them: Jonathan Homrighausen, *Planting Letters and Weaving Lines: Calligraphy, The Song of Songs, and The Saint John's Bible* (Collegeville, MN: Liturgical Press, 2022), 99.

NOTES

Rather than a betrayal of the text: Elizabeth Schrader and
Brandon Simonson, "'Rabbouni,' Which Means Lord:
Narrative Variants in John 20:16," *TC: A Journal of Biblical Textual Criticism* 26 (2022).

[Jesus] has appeared quietly, unostentatiously: Fyodor
Dostoevsky, *The Brothers Karamazov* (London: Penguin
Books, 2003), 325.

Rather than a Christian Christ whose suffering redeems:
Aaron Rosen, *Imagining Jewish Art: Encounters with the
Masters in Chagall, Guston, and Kitaj* (London: Routledge, 2020), 28.

Precious ideas like "all men are created equal": Eddie
Glaude Jr., *Democracy in Black: How Race Still Enslaves
the American Soul* (New York: Crown Publishers,
2016), 9.

Frees the cross from the false pieties of well-meaning Christians: James Cone, *The Cross and the Lynching Tree*
(Maryknoll, NY: Orbis Books, 2013), 161.

Encounter the real scandal of the cross: Cone, *Cross and the
Lynching Tree*, 158.

Au nom de la liberté de toutes les religions: William Rubin,
Modern Sacred Art and the Church of Assy (New York:
Columbia University Press, 1961), 149.

Without aiming them in the direction of the present day:
Osip Mandelstam, "Conversations about Dante," in *The
Selected Poems of Osip Mandelstam*, trans. Clarence Brown
and W. S. Merwin (New York: New York Review of
Books, 2004), 129.